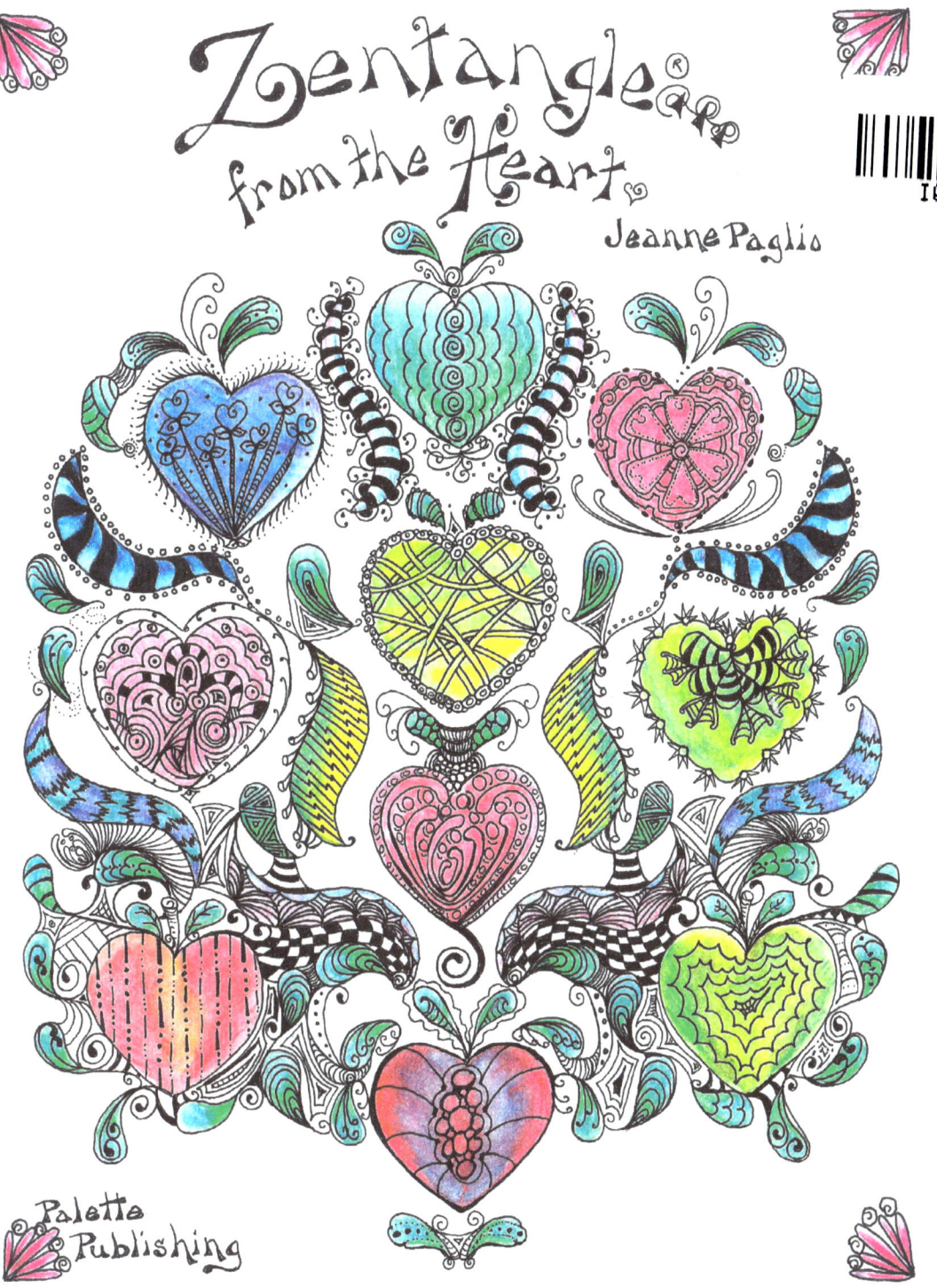

Copyright © 2013 Jeanne Paglio

Formatting by Hale Author Services

Dedication
To Terri Z.
a true friend

Doodling vs Zentangle®

There are lots of opinions concerning what the art of Zentangle® really is. Some say it's just doodling, while others are quick to make clear what Zentangle® really is. If you aren't aware of the difference between the two, read on...

Doodling—We've all done it. We know what it's like to sit and scribble, sketch little bits of things on paper, on our reports, in the margins of notebooks, and on meeting agendas. ☺ Admit it, we've all done this at one time or another. Some see it as a sign of boredom. Maybe so, but it's also another way to listen.

Zentangle®, as expressed on Zentangle.com, is a directed art form method with distinct benefits. By using repetitive marks, you clear your mind, allowing you to enter a relaxed state. Tangling increases your listening ability, and allows you to become more confident and expressive. As a directed art form, what you may think of as a doodle can become so much more. Tangling is empowering and uplifting when you relax and direct your attention to deliberately create beautiful artwork without any experience necessary.

For further information on this wonderful art form, visit www.Zentangle.com

Begin a tangling journey of your own by learning the easy-to-use Zentangle® method of art. Grab a notebook, create some 3 1/2" squares, gather a fine tip black pen (I use a Micron 01), a soft lead pencil, and a blending stump. Now...get started. You'll enjoy yourself and find peace of mind before you know it. ♥

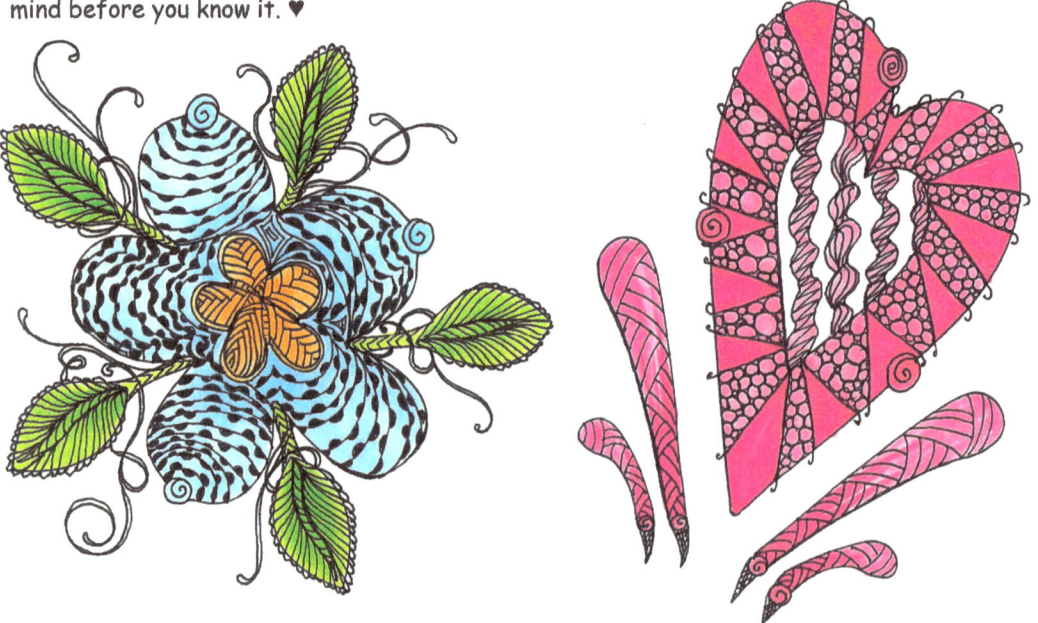

The Zentangle® art form and method was created by Rick Roberts and Maria Thomas and is copyrighted. Zentangle® is a registered trademark of Zentangle, Inc.

Let's look at the benefits of Zentangle®... I call these my 5 R's of tangling.

1. *Relax,* this is an extremely important part of life. To be sharp and have enough energy to live a full and healthy lifestyle, it's necessary to find time to relax. Zentangle® assists in creating a relaxed atmosphere which, in turn, will renew the energy needed to sustain us.
2. *Reflect* on what it is that makes life so hectic. Figure out how slow down and benefit by using Zentangle® to de-stress.
3. *Renew* your spirit. It's vital to feel good inside and out. Zentangle® with help to build confidence while you focus on what's important.
4. *Replenish* your energy level. It's rather like recharging a battery. Creating brief (or long) segments of time to tangle in a busy day, can help replenish energy.
5. *Reveal* the new you, the artist within. Zentangle® can bring about good, undeniable, changes without us realizing they have taken place.

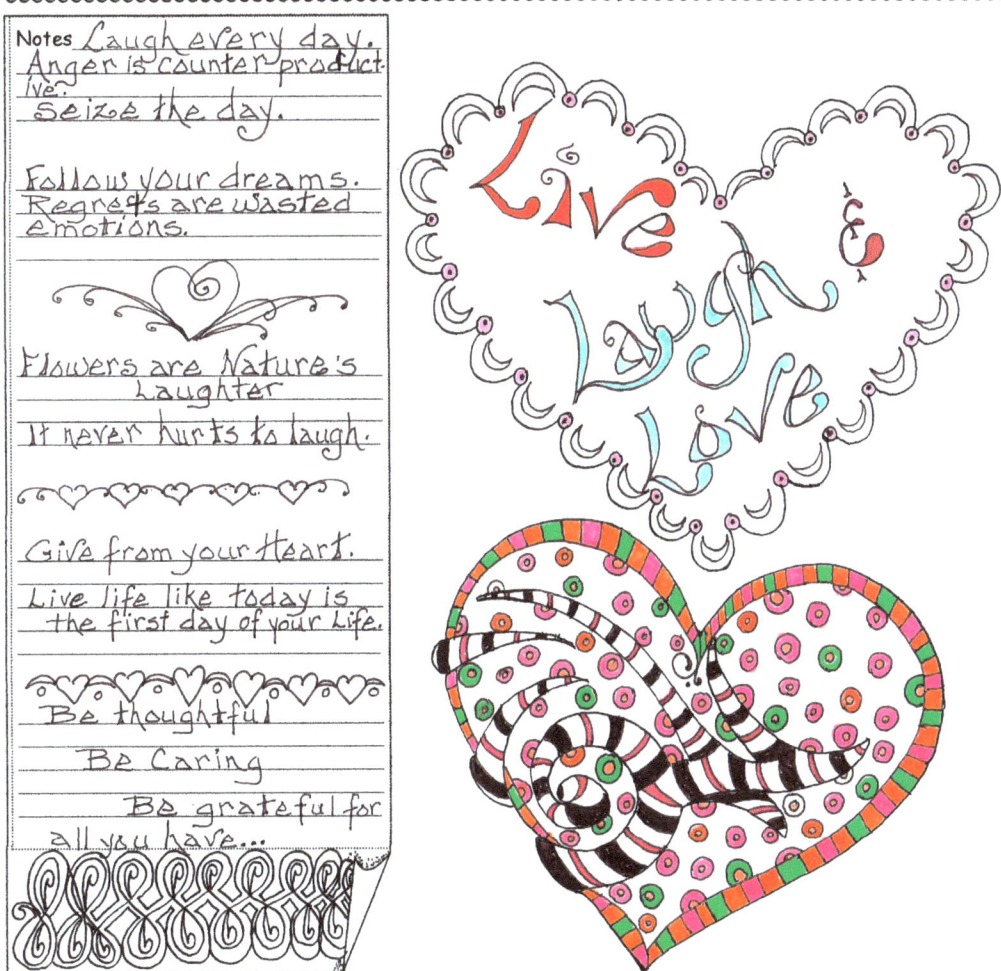

Notes: Laugh every day. Anger is counter productive. Seize the day.

Follow your dreams. Regrets are wasted emotions.

Flowers are Nature's Laughter

It never hurts to laugh.

Give from your Heart.

Live life like today is the first day of your Life.

Be thoughtful

Be Caring

Be grateful for all you have...

As we move through the year, and face life's challenges, there is a lot to be thankful for. Take a moment to stop and think about what is closest to your heart. Feel good things...Smiles, laughter, sunshine, fresh flowers, receiving a card, the sweet smell of fruit, the sun sparkling on the snow, or an opportunity to tangle for a while. Each and everyone of us can find at least one thing to smile about. Grab a pencil and put some of those thoughts here, surrounding or inside/outside a tangle.

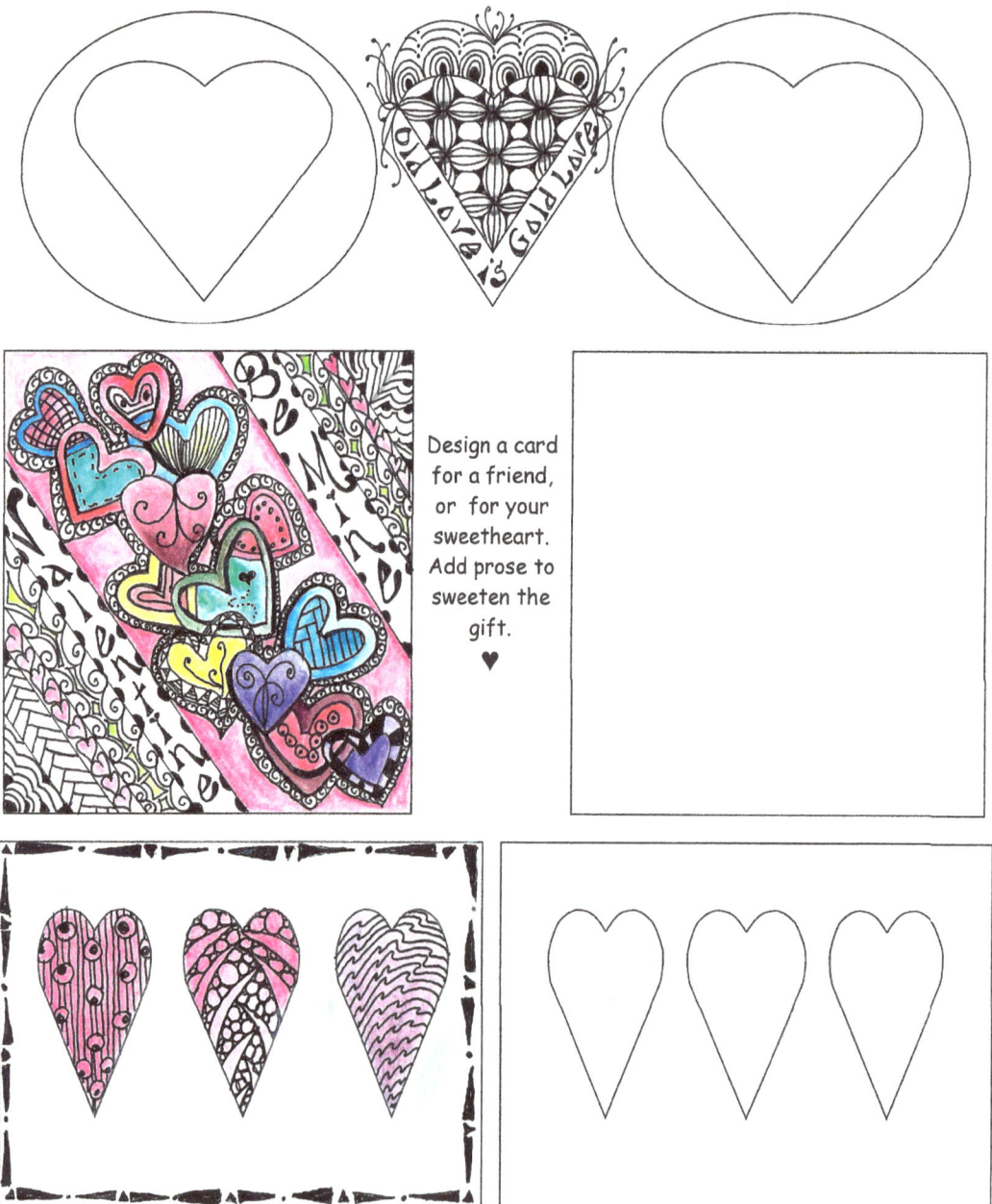

Design a card for a friend, or for your sweetheart. Add prose to sweeten the gift.
♥

Color Gradation Sampling

 140# watercolor paper is a perfect weight for water coloring. There are many ways to add color. Here's one way...First, place the colors you've chosen onto a palette, add a drop or two of water and mix each color, cleaning the paint brush in between mixes. Wet the watercolor paper using the clean paint brush and clean water. While the paper is moist, pick up a color on your brush and drop it onto the moist paper. The color will bloom, creating a lovely splash on the white paper. Pick up another color and drop it next to the first color on the tile. It, too, will bloom. Continue this until the paper has become filled with color. If the paper dries too quickly when adding colors, re-moisten the paper with a drop of clean water from your brush before dropping the color onto it. If the paper has dried and you've added color, then moisten your brush with water and gently move the color around on the paper.

 Another way to add color to tiles is to use markers. Copic markers are wonderful for this. They are easily blended, though they tend to bleed through the tile. If you plan to use the tile as an embellishment for a card, etc., then bleed-through won't matter. Markers dry quickly.

 Colored pencils are a great way to add color to tiles. They need to be blended into the paper first though, or the wax will clog the pen tip. I use a clear liquid, called Gamsol, and a blending stump (tortillion) to blend the colors. Gamsol is available at art and craft stores or can be ordered from online art supply dealers. Gamsol is easy to use, odorless, and works like a charm. Color the tile, dip the blending stump in Gamsol and blend the colors out. Dip the blender often to make sure it is wet enough to blend out the colors.

Initially, I begin my tangles using the standard method of using a square tile (a 3 1/2" square piece of paper). I add a dot in each corner and connect the dots using my pencil. What ever way the dots are connected (in a square or X shape or using squiggly lines, it doesn't matter) the tangles inserted in the spaces (and outside the spaces, if you wish). The entire rendering will be interesting and eye-catching. When round tiles are used, dots can be added (or not). I like to find the center of the circle, place a dot there and create my tangles from that point on. If I use watercolor paper or card stock, I add color first, let it dry thoroughly, and then continue with tangling from there. Choosing to work on already colored paper is fun, as well. Challenge ~ yourself in both ways, using dots or creating a tile without dots as a starting point. It's up to you. There is no wrong way to tangle. And remember…

<p align="center">❧" There are no mistakes, only opportunities". ☙</p>

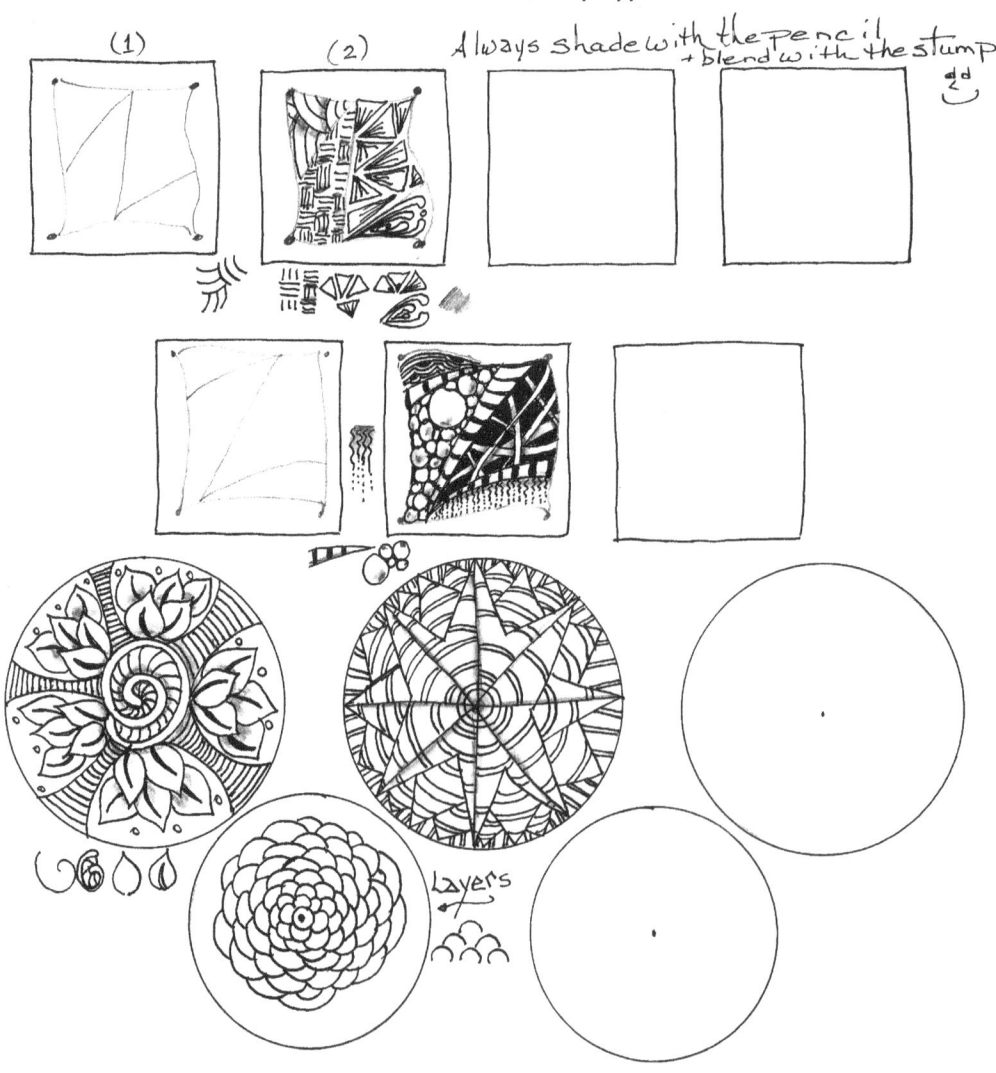

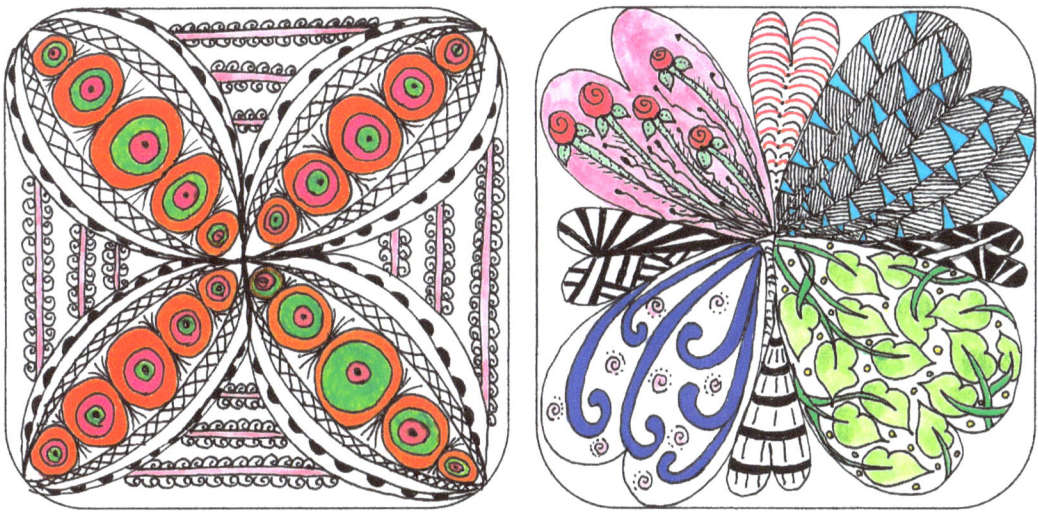

There are no prerequisites for tangling. Taking a class to learn the basic concept of the benefits and process behind Zentangle® is a good idea, but if it's not possible, tangling books offer a sound alternative. Using the examples in this and other tangling books on the market, can bring you much satisfaction in the outcome of this useful, interesting, and beneficial art form.

Here are a variety of repetitious marks that created the above tangled tiles. Begin with a 3 1/2" square of paper (it's less intimidating than a full size sheet of paper). It's as easy as pie!! Keep going, don't stop until the tile is full.

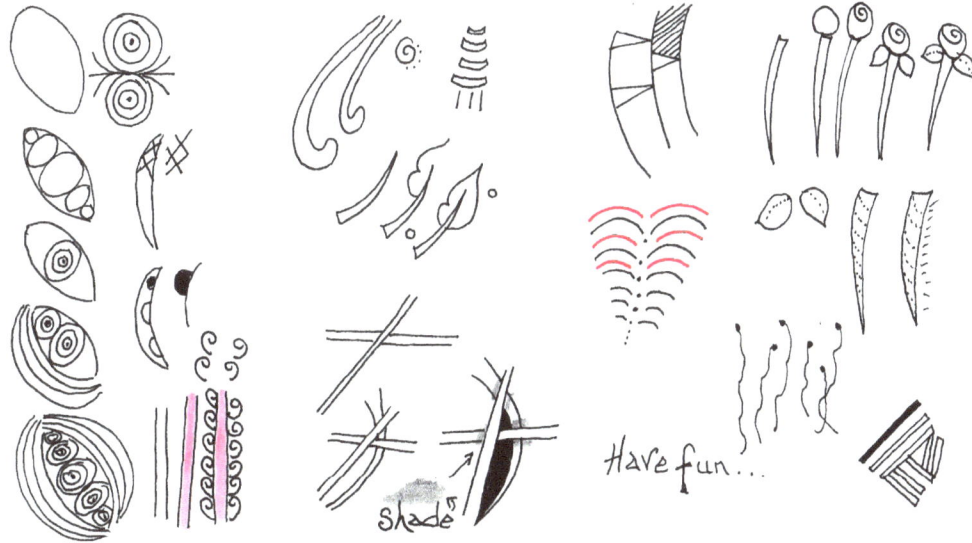

Now make your own calendar page. Copy or print a calendar page on a computer printer or Copier. Tangle a month, and tangle the days. Decorate around the numbers. Leave enough space for notes inside the daily blocks.

Sun	Mon	Tue	Wed	Thu	Fri	Sat
						1
2	3	4	5	6	7	8
9	10	11	12	13	14	15
16	17	18	19	20	21	22
23	24	25	26	27	28	29
30	31					

Valentines and hearts are two of my favorite things. I enjoy the variety of expressions that accompany valentines, while hearts are simply fun to create and tangle.

There are many creative tangles in this book, and spaces for more to be added, with a bit of Valentine's history for you to enjoy.

Hearts used to express our feelings offer an uplifting sense of being.

February is the month for romance and valentine cards. But, any time is a good time to share hearts and flowers, hearts with swirls, hearts and whatever else comes to mind...

Enjoy!!

Jeanne ♥

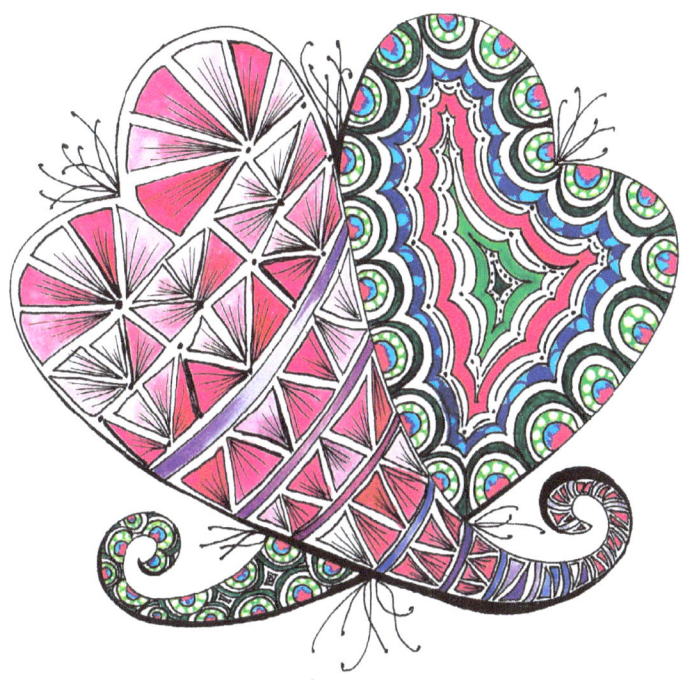

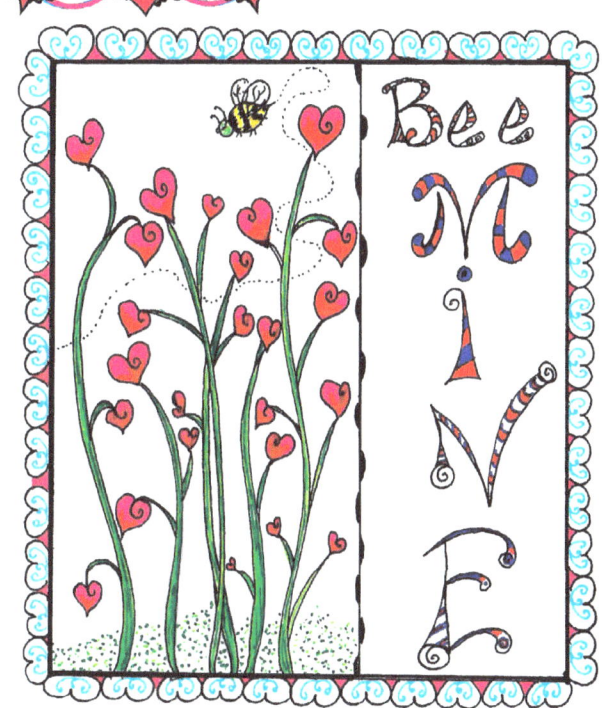

Originally, Valentine's Day was claimed to be the time when a pagan festival took place. In mid February, Romans would commemorate the anniversary of St. Valentine's death, which took place around 270 A.D.

Other claims tend toward the St. Valentine's feast as an effort to Christianize the celebration of Lupercalia, a pagan ceremony regarding fertility, dedicated to the Roman god of agriculture, Faunus, and to Roman founders Romulus and Remus.

Need a special birthday or a Valentine present that lasts all year long?

Cut out 12 hearts or tiles, tangle each one. On the reverse side, offer a unique gift for each month such as a free movie, a date for pizza, a special time to tangle, a shopping trip, or a visit to a local museum, etc. The gifts needn't be expensive, as long as each one includes time spent with the recipient so they feel special, which is the point of the gift.

Assemble the stack using a ribbon or brad and make an envelope or gift bag to present it in. ♥♥♥

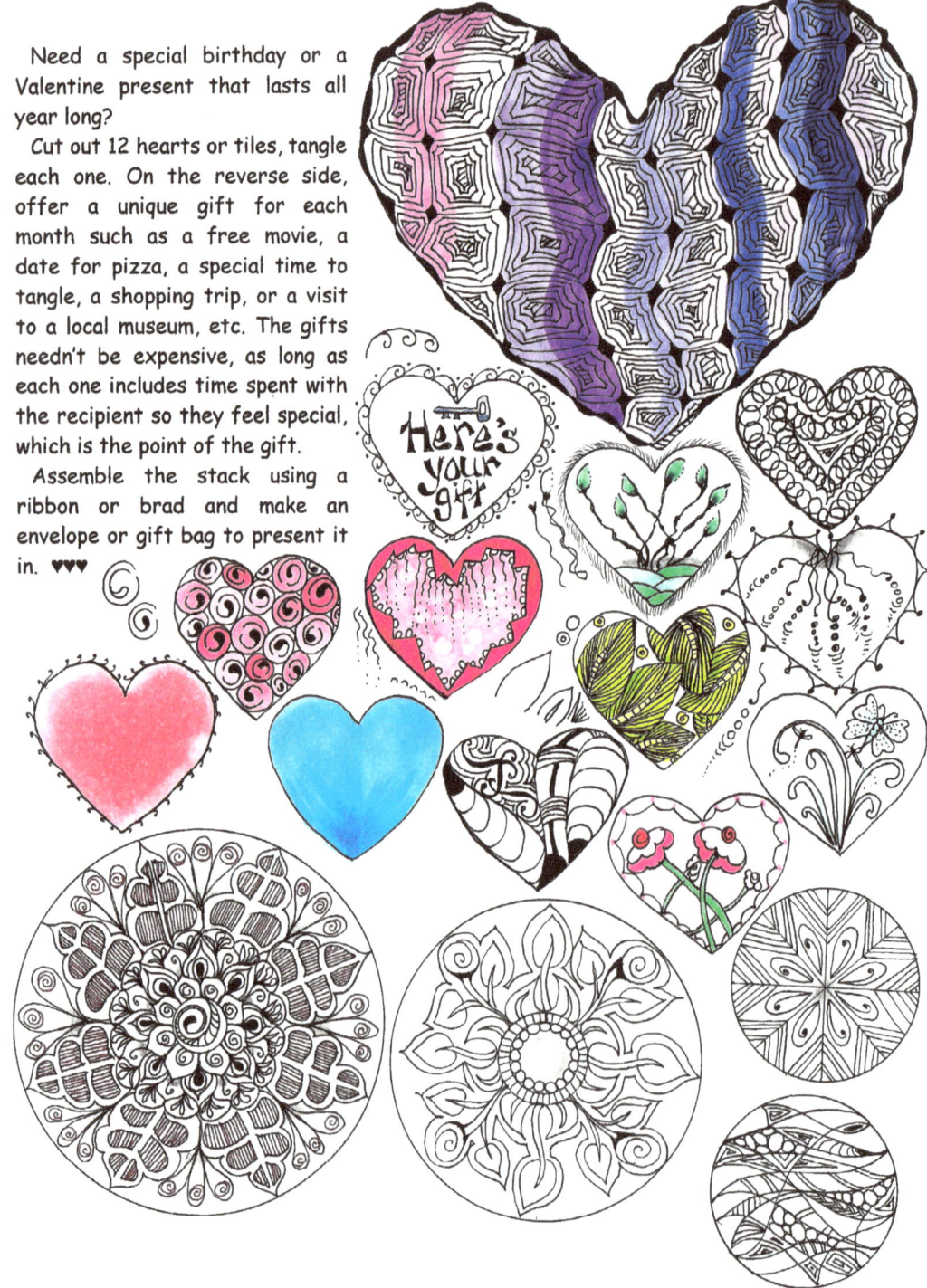

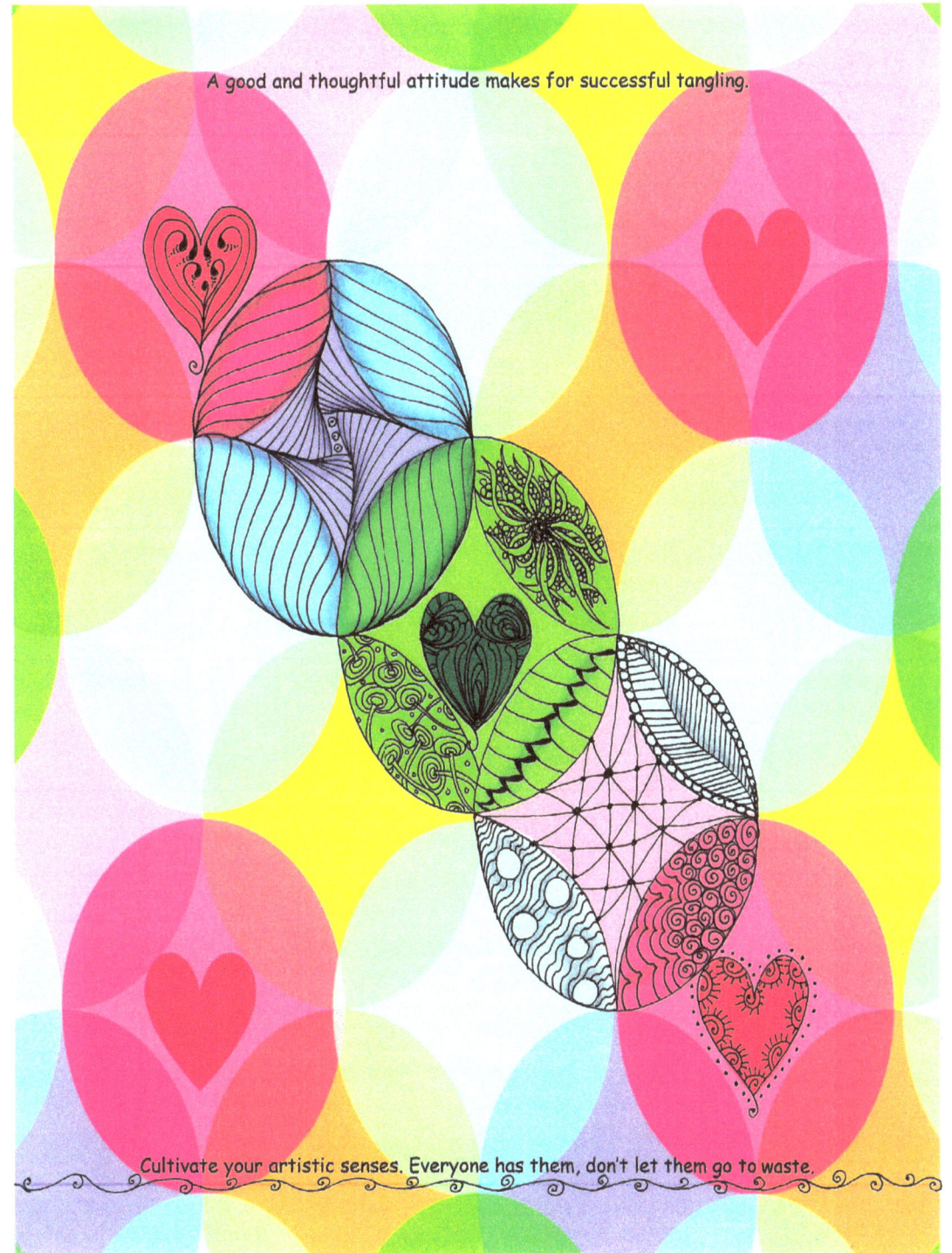

Zentangle is perfect for heart shapes of any type or size. Fill in some of these using your own designs or the examples provided.

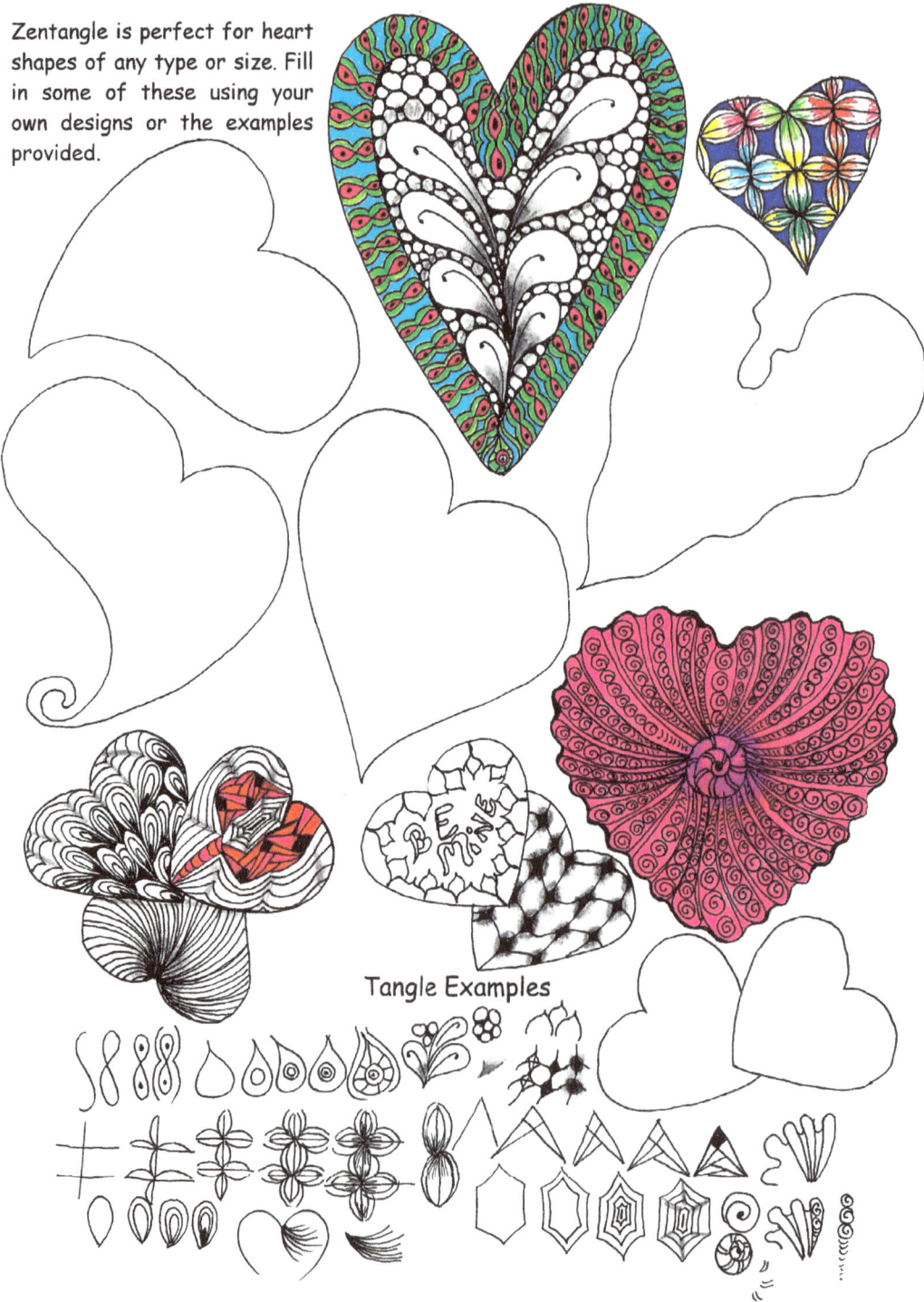

Tangle Examples

Legend states that New England's Valentine industry was inspired by a Massachusetts woman, Esther A. Howland, who had received an English Valentine. Ms Howland, studying at Mount Holyoke College in Massachusetts at the time, started making and distributing Valentines cards. Due to her diligence, Worcester. Massachusetts became home to American Valentine making. Through the mid-1850's sending Valentine's Day cards was popular and increased after the Civil War ended. Victorian cards, and those of today, continue to be works of art. Crafters and artisan's alike are making their own cards, not just Valentine cards, but a variety of cards for all occasions using found objects, stickers, cut paper, silk ribbon, thread and buttons, along with many other embellishments.

Tangled tiles of pieces of them, in color or simply black and white, generate amazing cards that can be kept and framed as art.

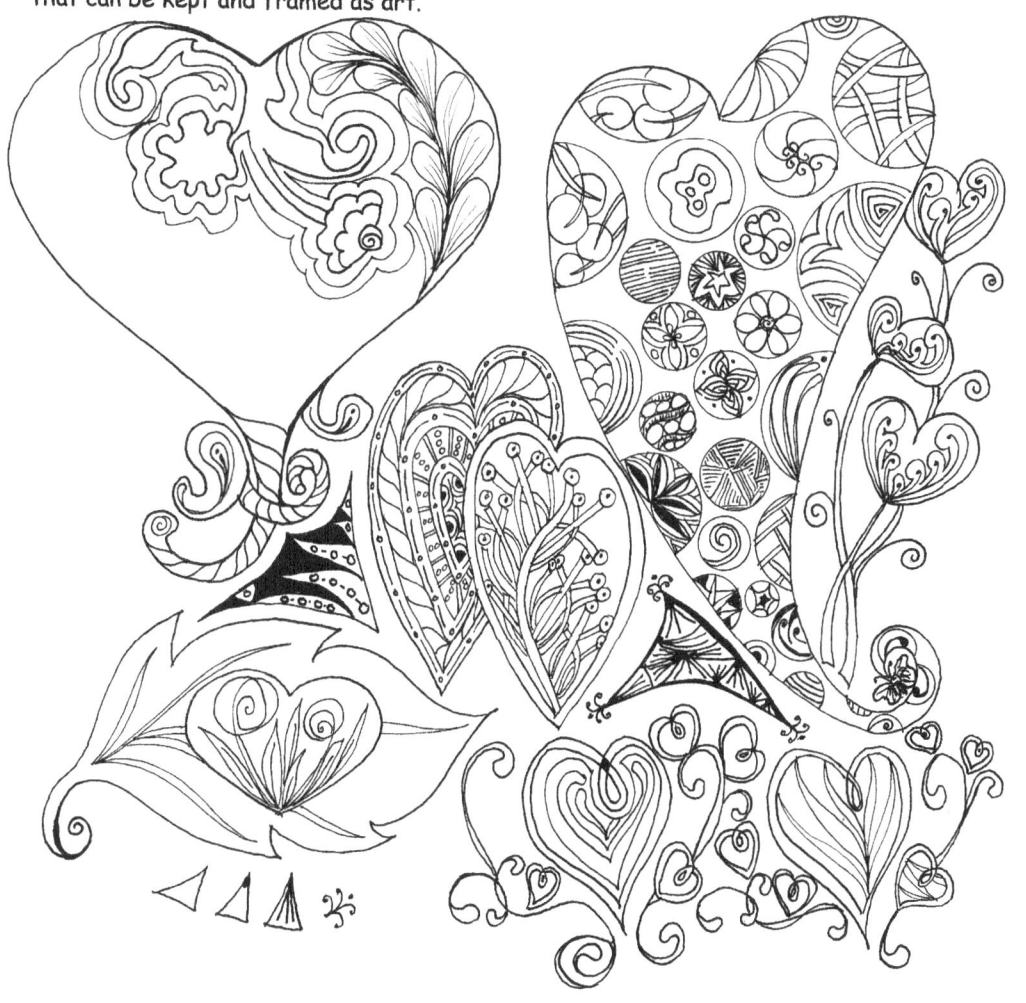

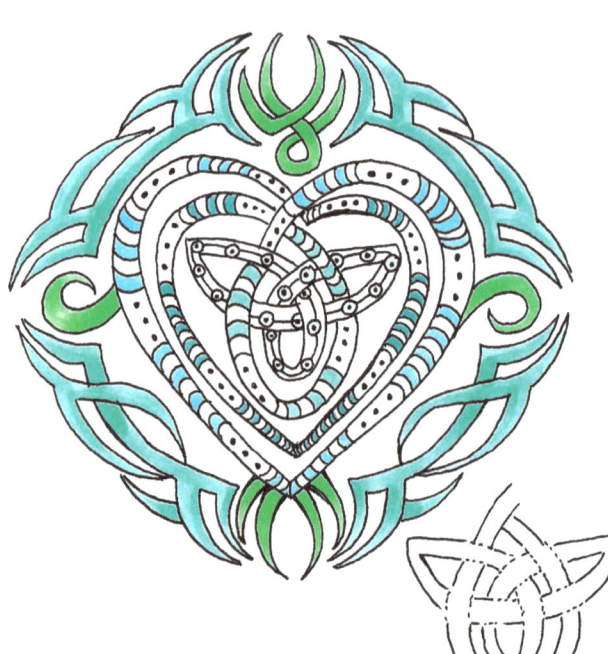

Celtic designs weave throughout, but this one has a few spaces added for interest.

Begin with the first line of the heart, weave the lines to where they will intersect, leave dashes for the next weave. The dashed lines are where weaves intersect.

When drawing the design, try using several lead weights (B, 2B, 4B, 6B) to stay focused on the line connections and their intersections.

The outer, decorative, line work can be done using an ink pen or a single lead weight pencil. All final lines (drawing over the pencil marks) will be done in pen.

Allow the ink to dry completely prior to erasing any pencil lines that remain.

Heart shapes have long been used in Valentines. They reached the height of popularity during the Victorian era, but are still very popular today.

From whimsy, to sentimental, many designs were heavily embellished with ribbons, dried flowers, real feathers, and embossing. Some Victorian era cards included marriage licenses.

Poems and sayings in these cards were effusive and treasured by women and often kept by men who had received them from an admirer.

The earliest known and proven valentines were composed for Valentine's Day during the 14th century in England and France.

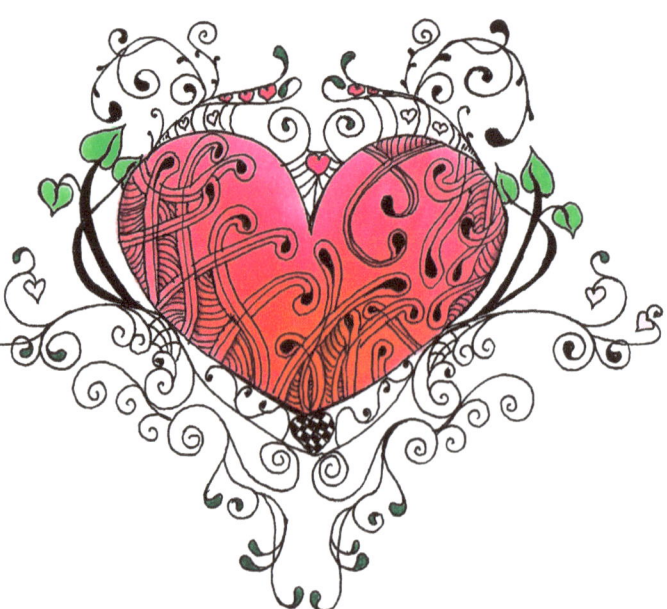

Print styles—Try various fonts on your computer. They make sayings more interesting.

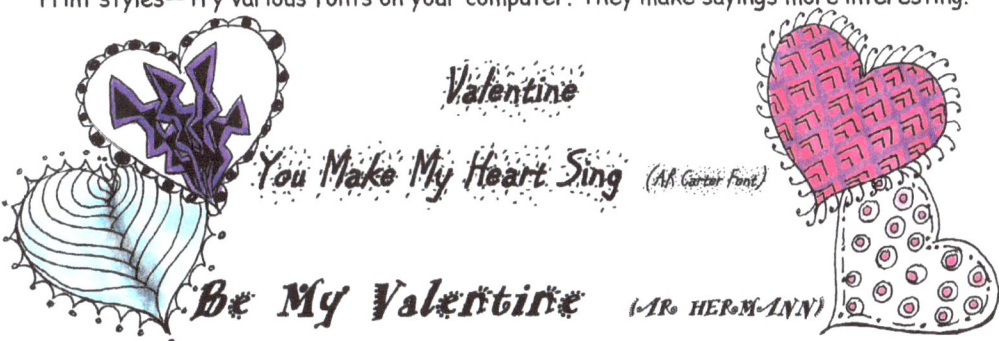

Valentine

You Make My Heart Sing (AR Carter font)

Be My Valentine (AR HERMANN)

LOVE IS A PRESENT I WILL GIVE YOU EVERY DAY
(AR DARLING FONT)

All things grow with love (Curlz MT font)

The best gifts are those tied with heartstrings (Giddyup Std)

All things flourish with Love (Gigi font)

Friends become chosen Family (Jokerman font)

Friends are always at home in our hearts (Chiller font)

Together is the nicest place to be... (Gabriola font)

Here's a sampling of hearts, square tiles, and round tiles.

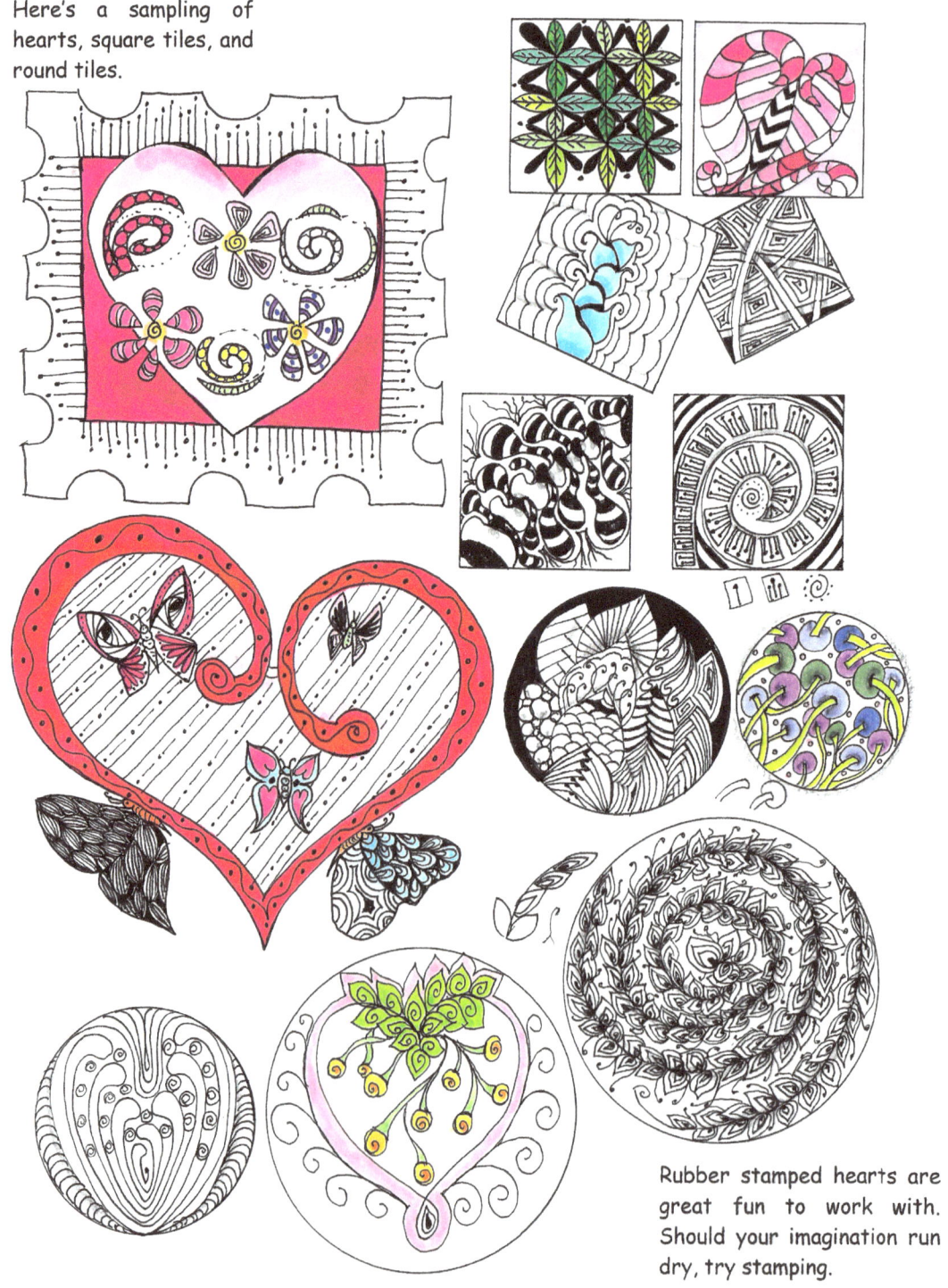

Rubber stamped hearts are great fun to work with. Should your imagination run dry, try stamping.

Here are additional samples. Try some to see what you can do!!

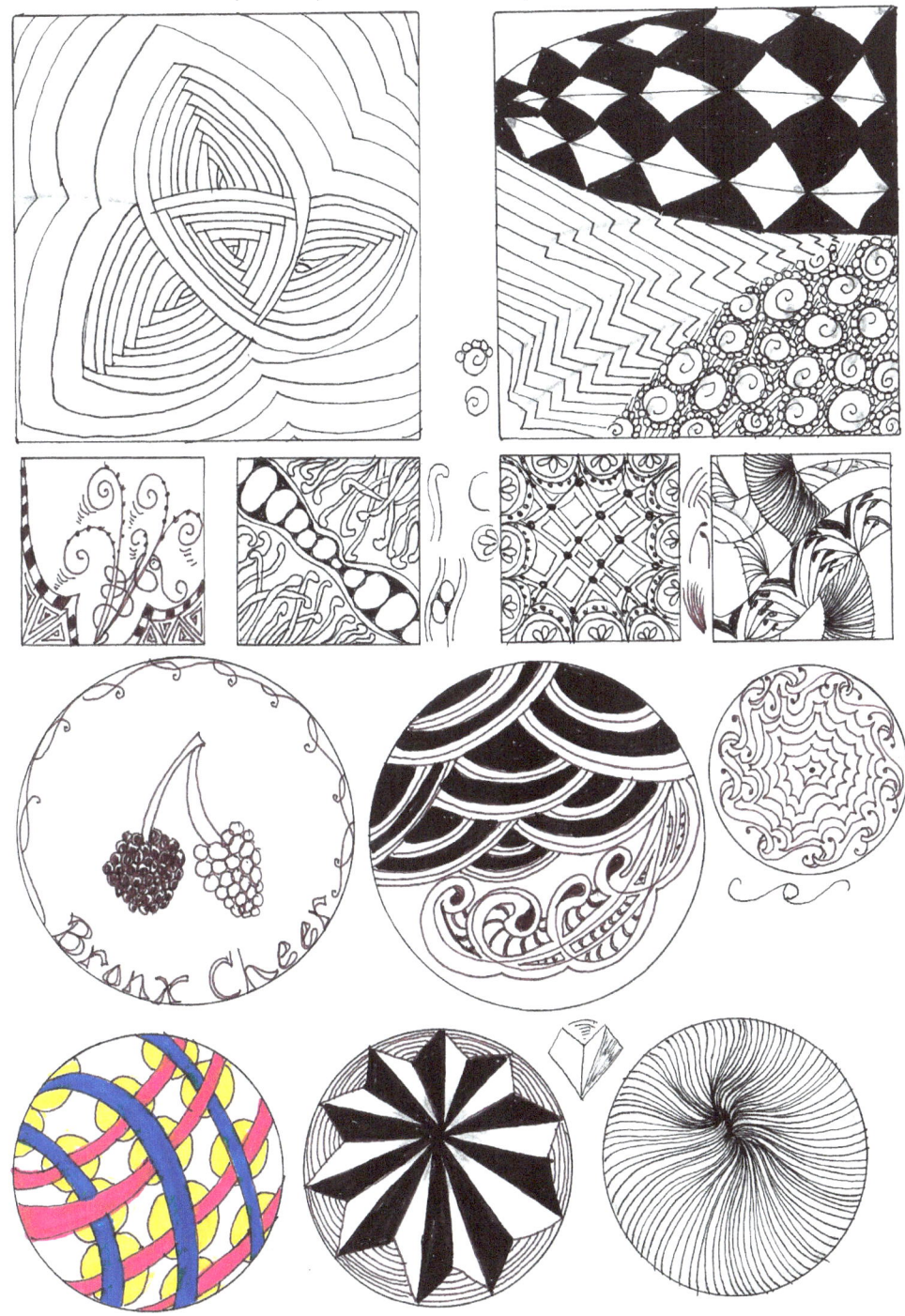

Tangle to your hearts content.
It's value is amazing!
Nesting brings ideas...
Tangle your nest!

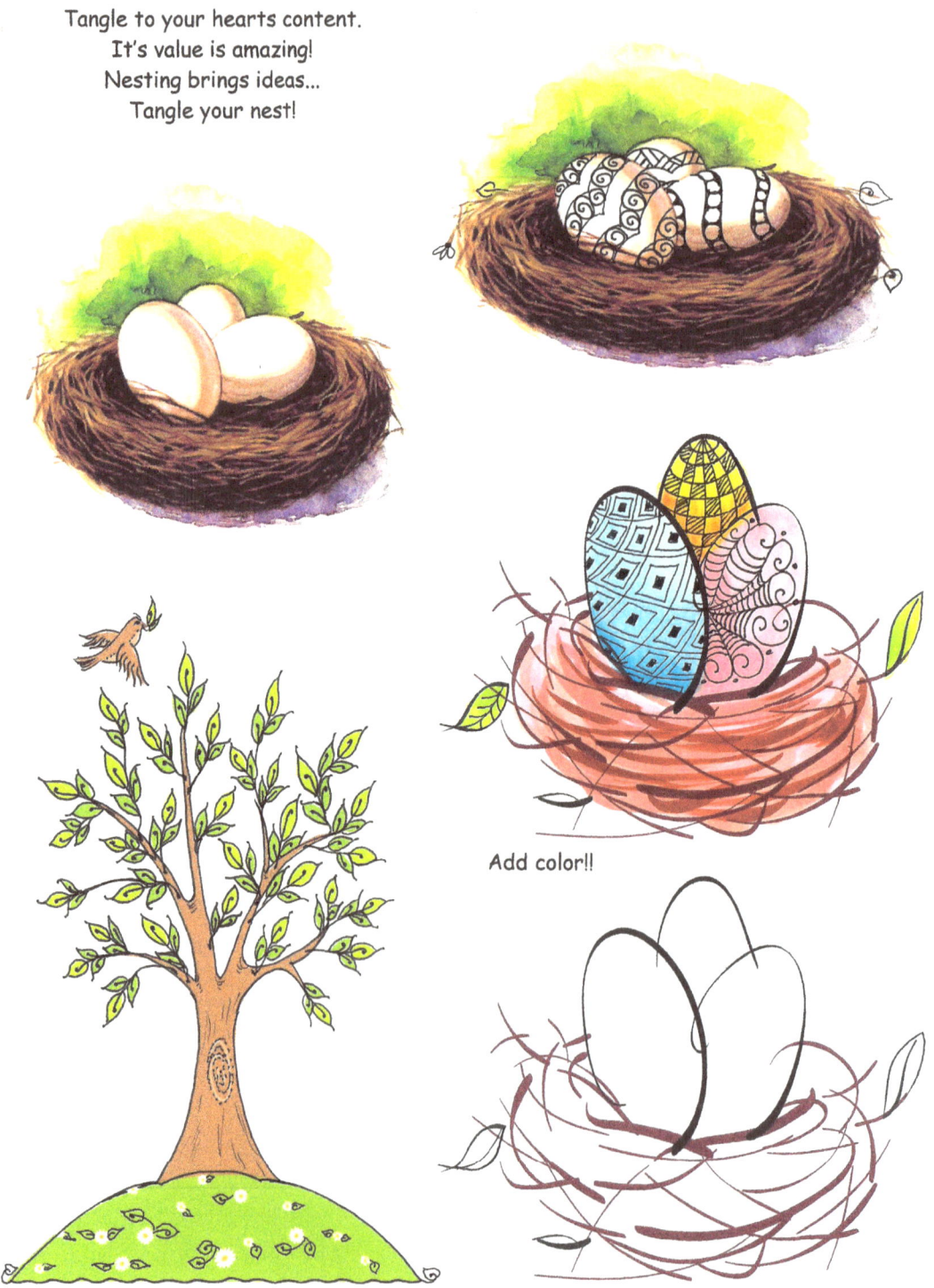

Add color!!

Working in black and white is fun and easy. To add color taxes the brain. Add interest to designs by varying the colors or the use of black on white when tangling. Add depth by shading areas that need it, so the picture won't look flat and plain. Drawings take on dimension once shadows are put in place.

Figure out where your light source is coming from. Upper left or right, lower left or right, or from the top or bottom of the picture. Then add shadows.

So often in tangling, we place the shadows where we please, and that's fine. In a picture such as this, though, it's important to add shading to create dimension and depth.

A few shadows have been marked in the picture as examples of the sun's direction, which creates shadows and adds depth.

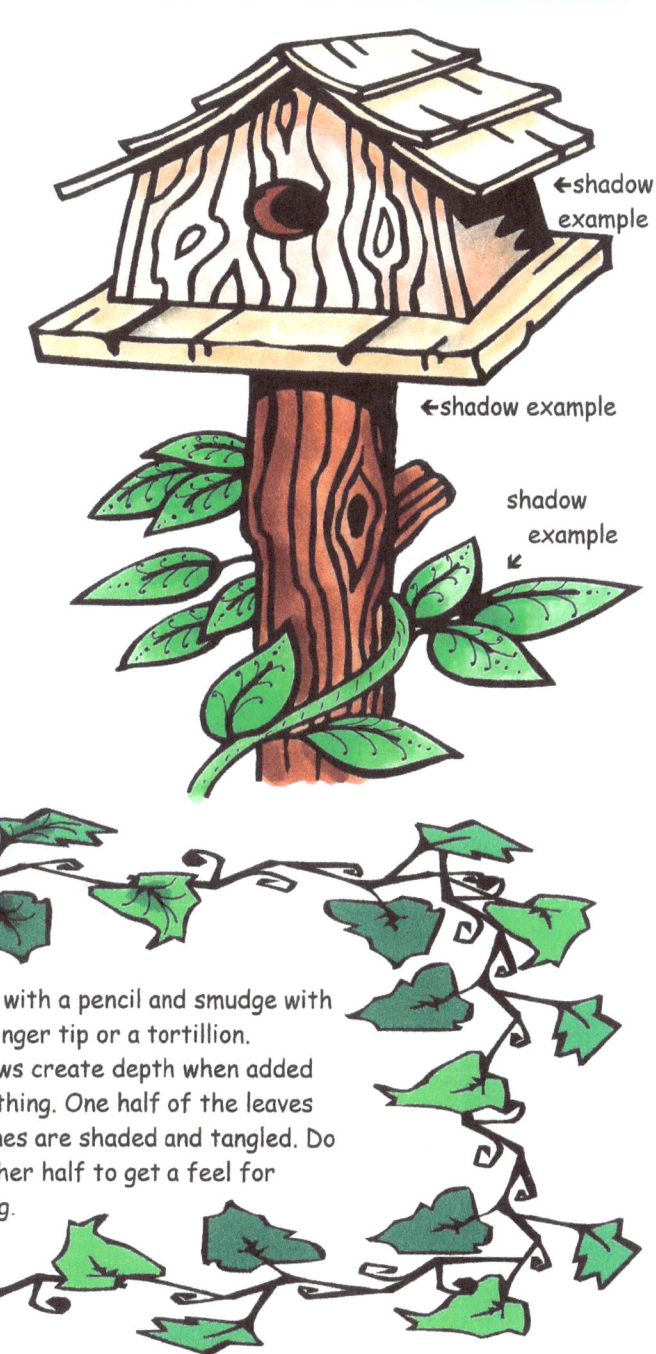

Create you're haven, a place of fun and relaxation.

←shadow example

←shadow example

shadow example

Shade with a pencil and smudge with your finger tip or a tortillion. Shadows create depth when added to anything. One half of the leaves and vines are shaded and tangled. Do the other half to get a feel for shading.

List your talents, for there are many. Place a Zentangle heart among them.

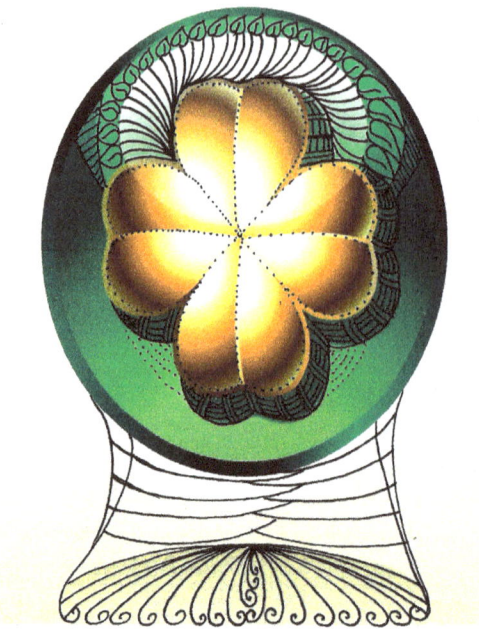

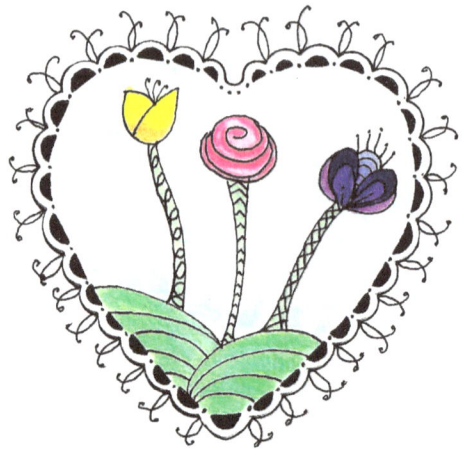

There's someone who cares for you, just because you're you. Let your light shine!

Reach for the stars, they're within your grasp. Believe!

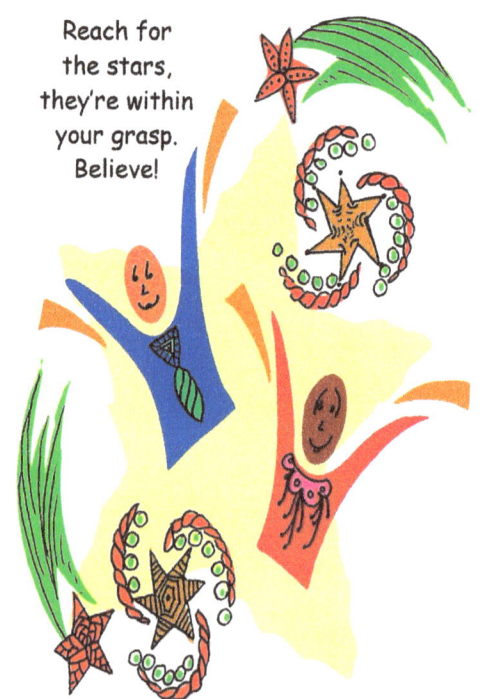

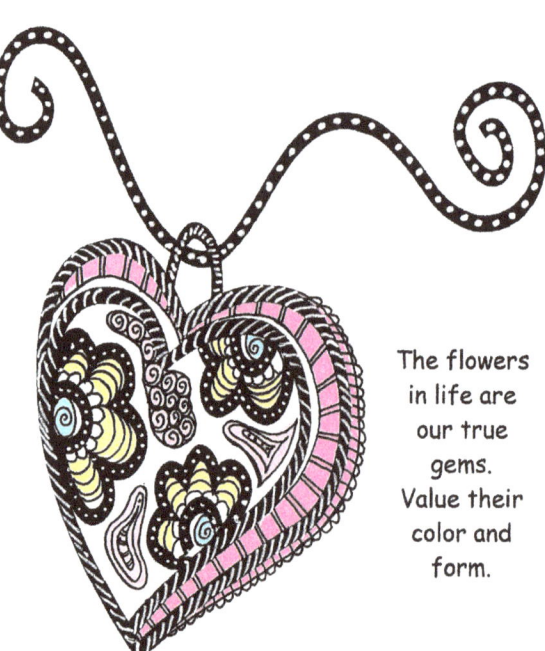

The flowers in life are our true gems. Value their color and form.

When there's an open mind, there will always be a frontier. Have an open mind when it comes to tangling. Let your imagination rule, and the limits are endless. A closed mind allows a narrow view. Open up your possibilities, free your spirit, and let your creative juices flow. It's not harmful, but healthful!!!

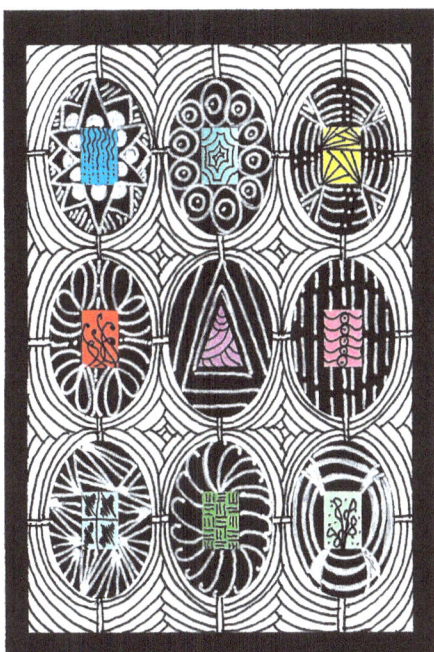

We can't do everything at once; but we can do something at once.
Tangle Daily!! It's good for you!!!!

Choose to tangle, it will make life more pleasant. ♥

23

Tangle...It's value is truly amazing!!!

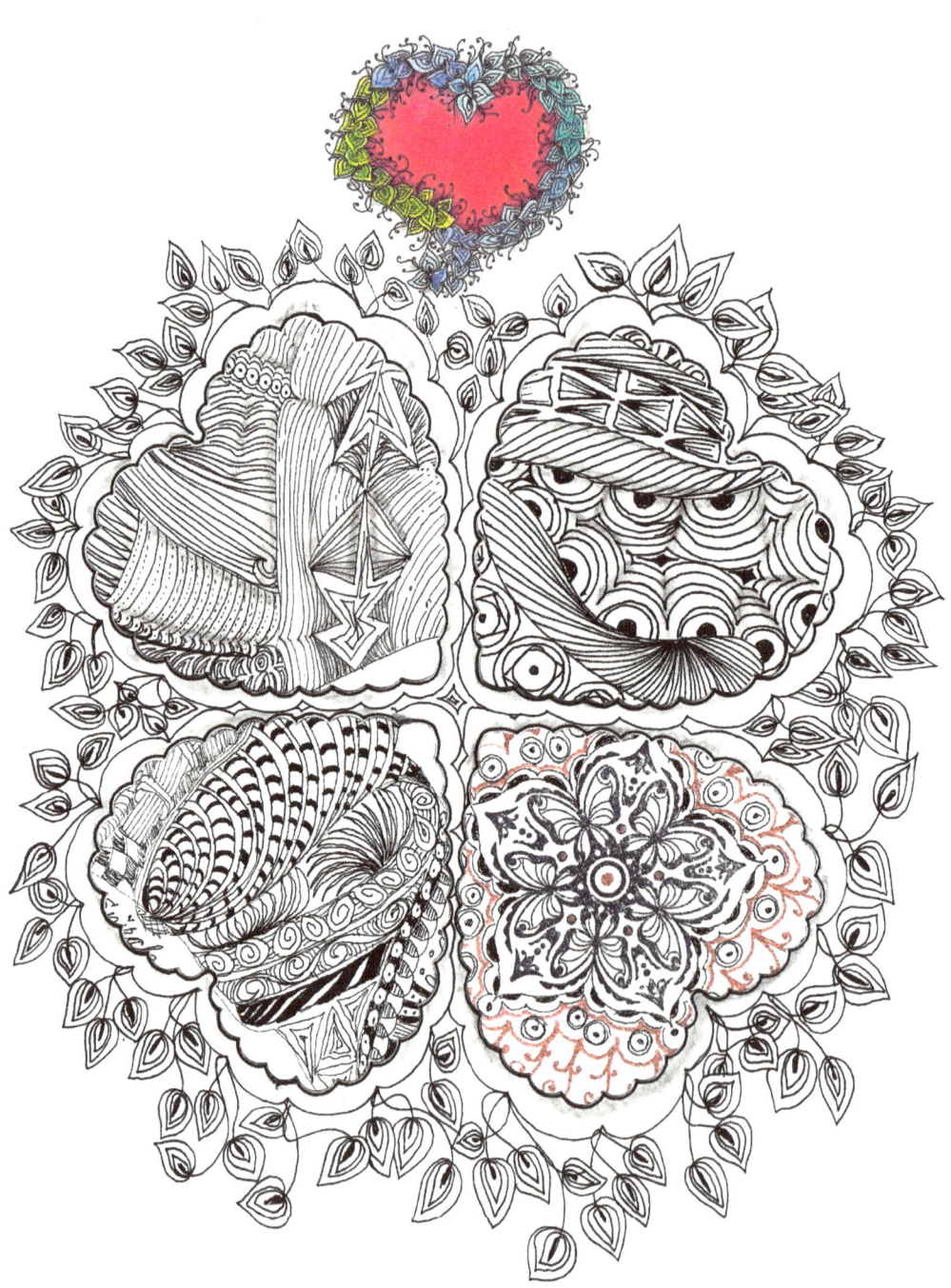

Moleskin sketchbooks are a neat way to keep tangles organized. Fill each page and add some words of wisdom to them. They make a nice keepsake.

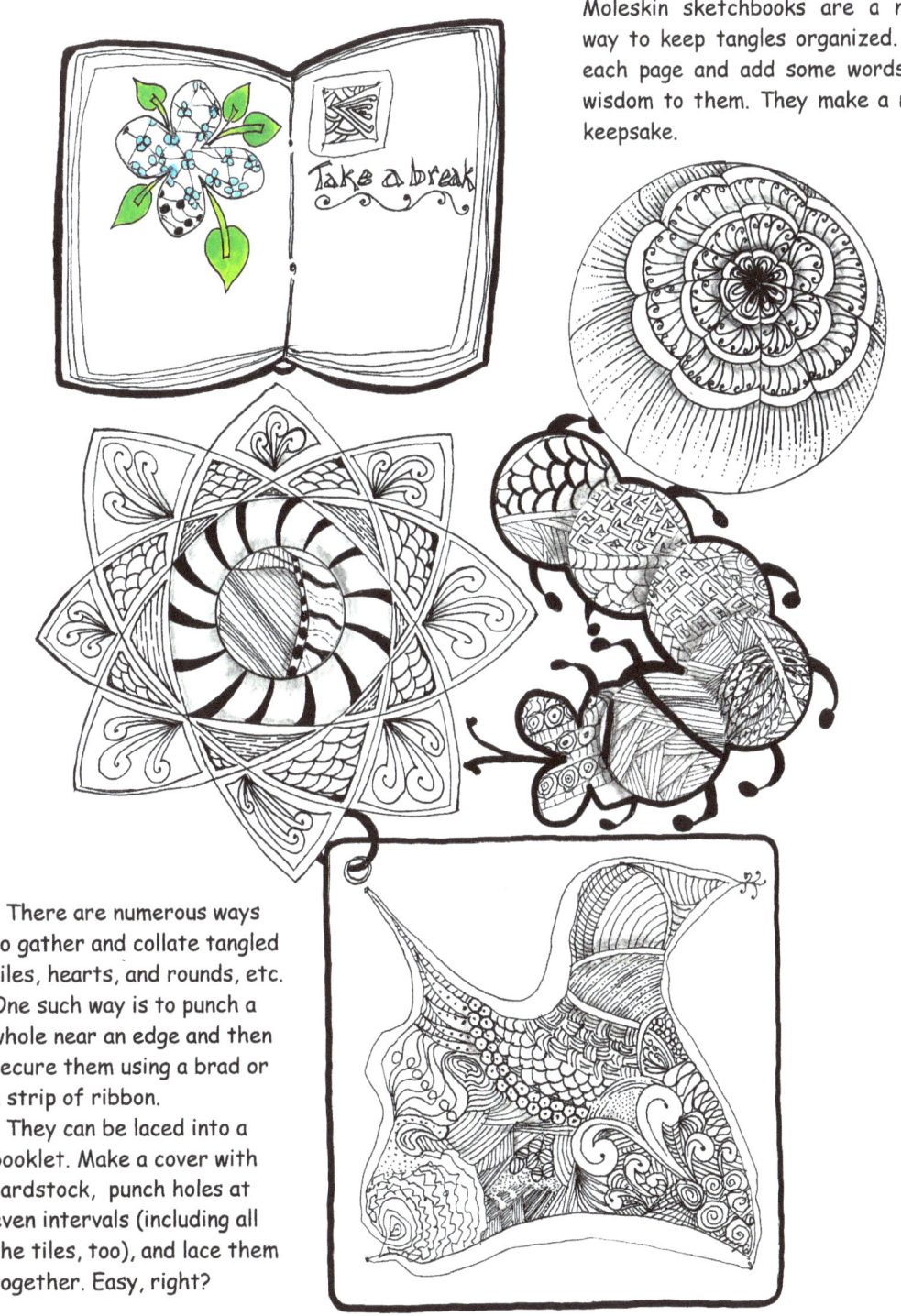

There are numerous ways to gather and collate tangled tiles, hearts, and rounds, etc. One such way is to punch a whole near an edge and then secure them using a brad or a strip of ribbon.

They can be laced into a booklet. Make a cover with cardstock, punch holes at even intervals (including all the tiles, too), and lace them together. Easy, right?

Denim is perfect for tangling. It wears well, fabric markers will stay bright and won't fade quickly. Colored fabric easily accepts white or dark ink and an IDenti-pen manufactured and distributed by Sakura™ works beautifully. White denim begs for tangling. Whenever I see white denim, my artistic senses soar, and my fingers itch to get my pen out and give it a go. So, what's in your closet that requires tangling to make it scream "Look at Me".

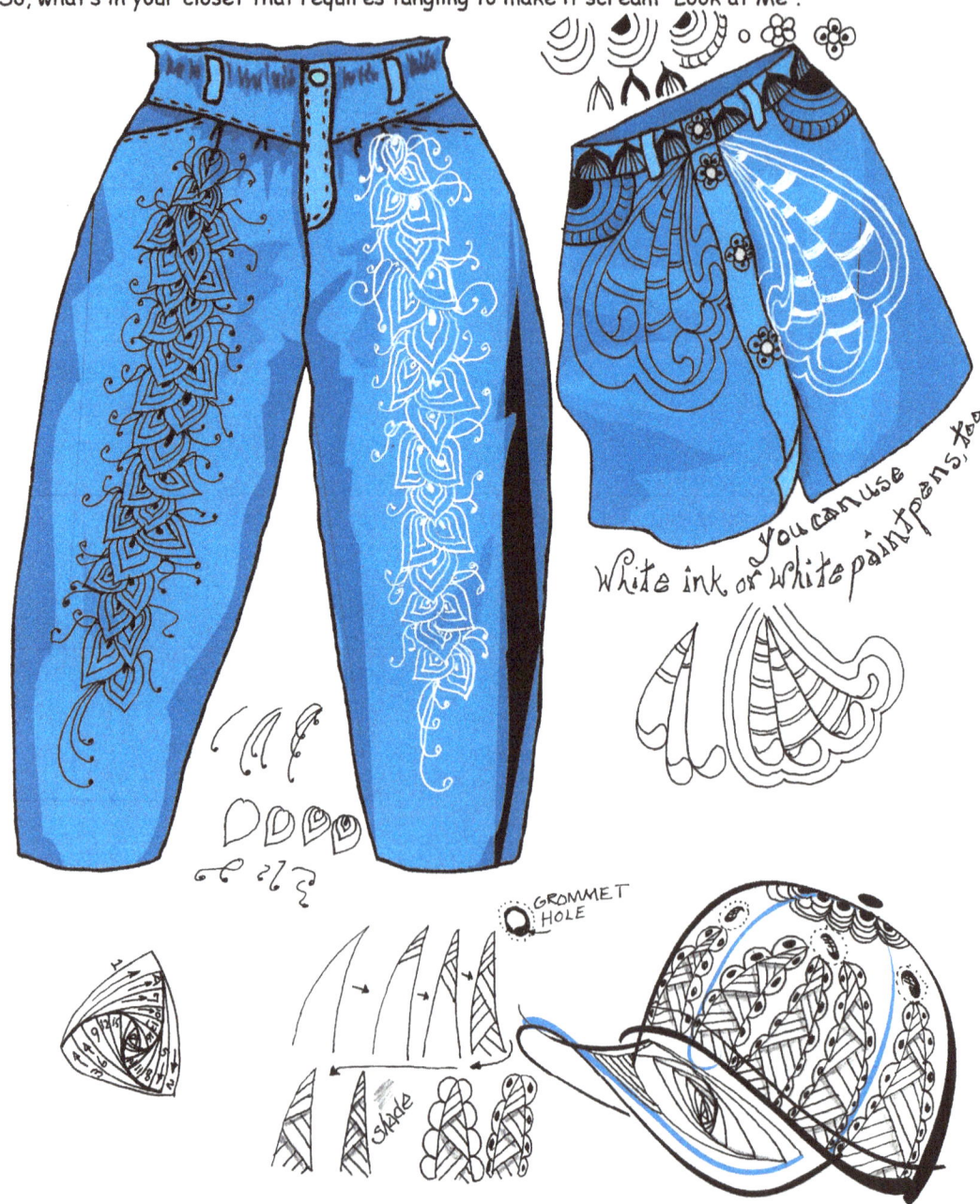

Girls, big or small, young or old, love hearts.

Tangled sneakers filled with tangled hearts are sure to be a hit. It's simple. Use a fabric pen, and/or fabric markers to draw or trace different sized hearts on a pair of sneakers (both shoes can be different, things are more interesting that way). When the sneakers are given to their new owner, you'll be rewarded with their excitement and pleasure. ♂

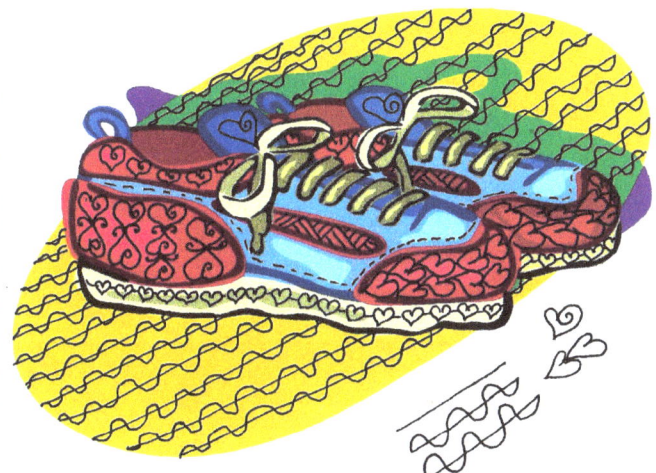

Nearly everyone wears T-shirts. A tangled T-shirt will bring long-lasting joy to those who have them. ⋈

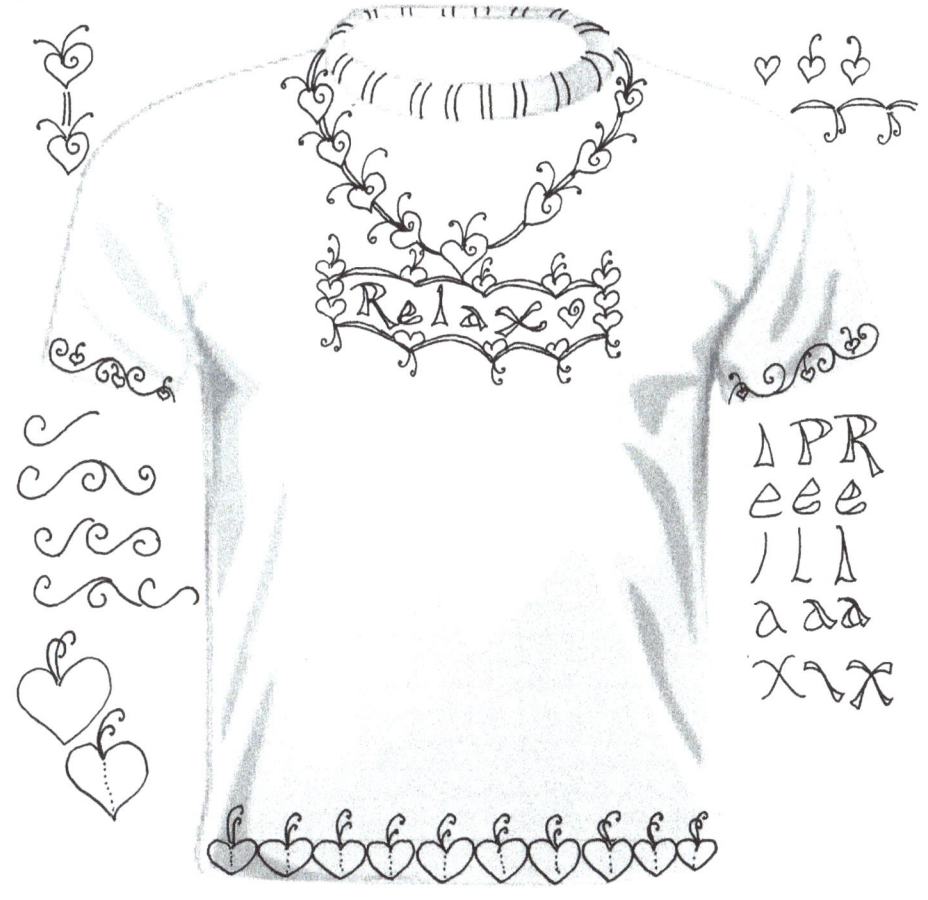

Hearts needn't be the focus of a tangle, but an added perspective to one.

For example, use a square, round, or rectangular shaped tile (paper) to create a tangle. Place the tangle anywhere on that given tile, and add a heart every so often, or even just once, for interest to let the recipient know how you feel.

Sample marks for your use.

Random Acts of Kindness

Life has sharp edges. Round them out using random acts of kindness. Help a person in need, a simple act will dull a jagged edge.

Harsh words come easier to some than to others. A kind word fills a void with comfort and joy, rather than sadness and defeat.

What random act of kindness has occurred in your life?

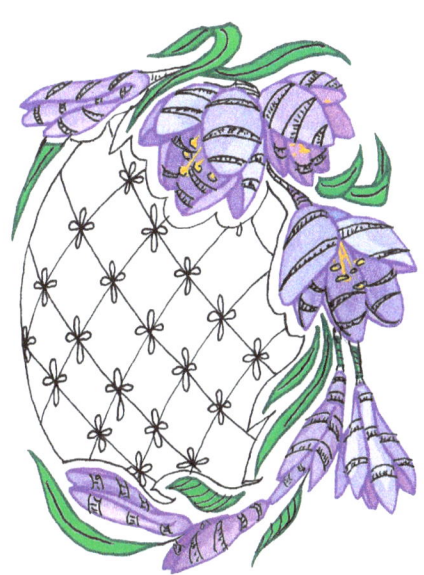

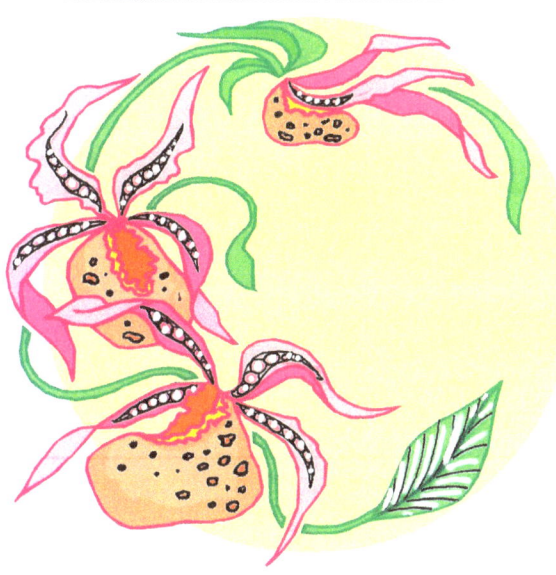

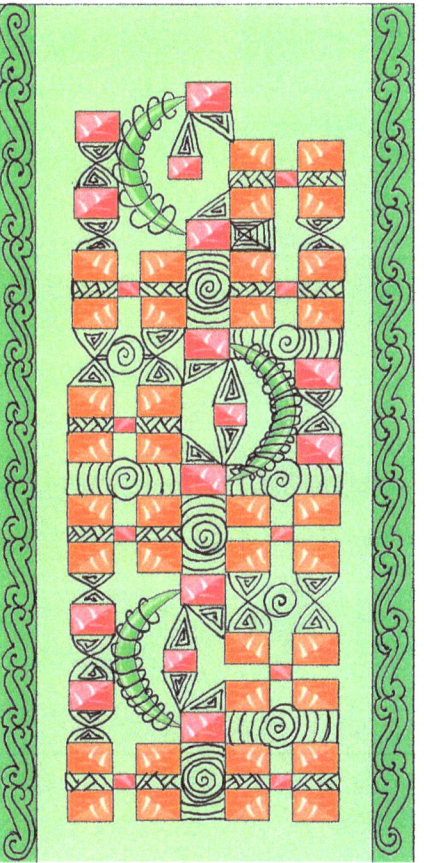

Tangle Samples

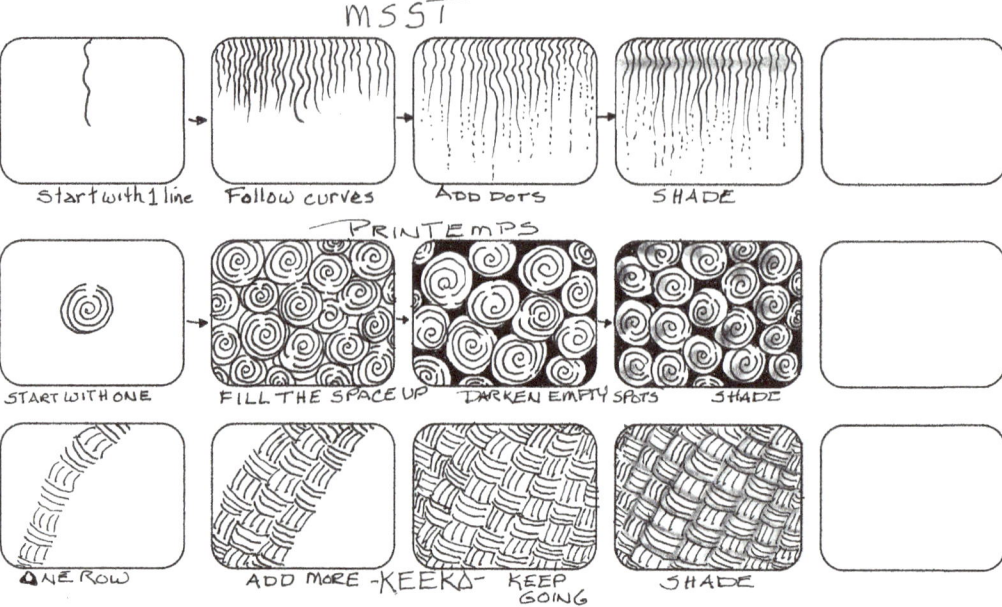

Rubber Stamp Tangled Samples

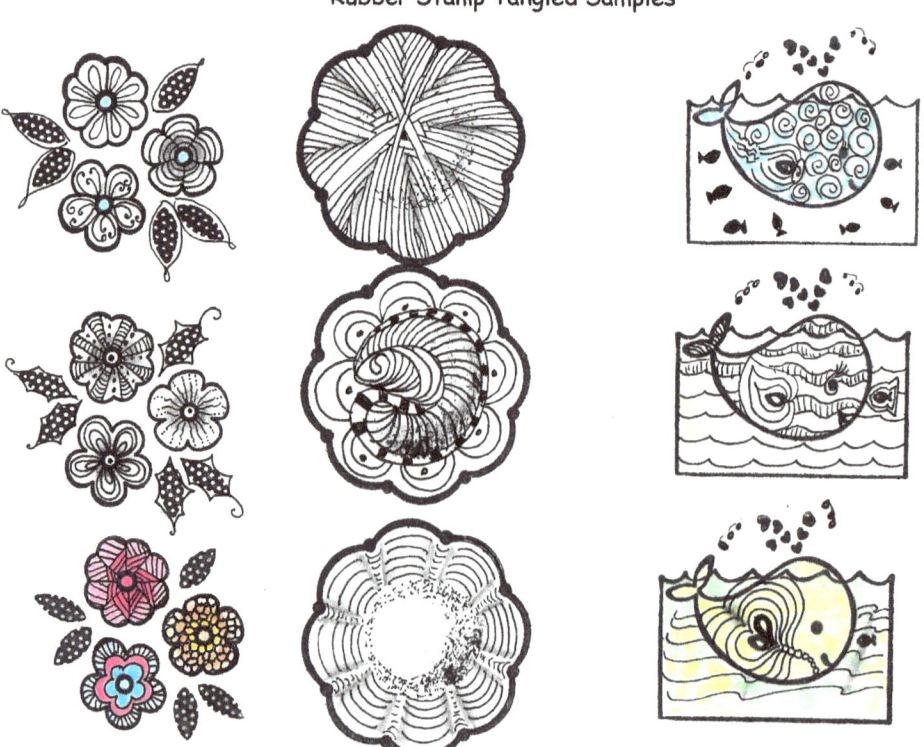

The only way to have a friend....is to be one.
Show friendship by tangling a heart and offering it to someone else.
It's a sign of goodwill.

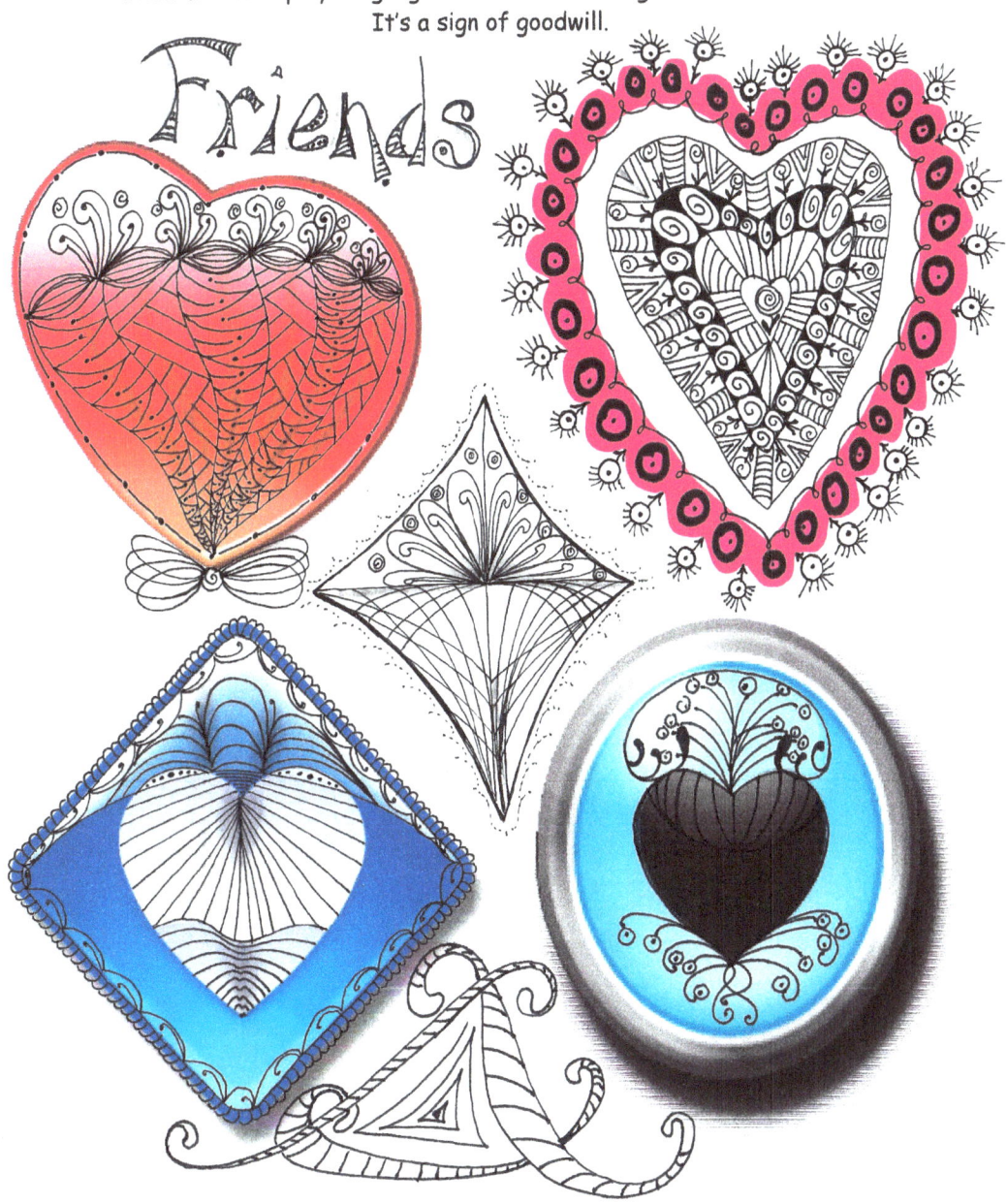

A word fitly spoken, is like apples of gold in pictures of silver.
Proverbs 25:11

Step 1 ←
Step 2 ←
Step 3 ←
Step 4 ←

Fill the smallest space

Step 5 ←

Not only are apples delicious and vitamin rich, but they are picturesque. How often have apples been featured in paintings, magazine adds, the alphabet? A is for Apple, and an Apple for the teacher, is age old. This tasty fruit also comes in a variety of colors. Red, green, yellow, and in various shades of all those colors, as well.

Apples are used in stories, those in the Bible, and in children's books such as Snow White.

When I was a child, an apple a day...was my mother's mantra which she used to encourage me to eat apples. We had a number of crab apple trees in the front yard (great for making jelly), and I used to eat them as a snack.

Enjoy these apples. Tangle them to your heart's content.

Creative Sayings...
What sunshine is to flowers, smiles are to humanity.
Keep your enthusiasms, and forget your birthdays—formula for youth!
One of the great arts of living is the art of forgetting.
All people smile in the same language.
The world belongs to the enthusiast who keeps cool.

Take Time to Create

Taking time from a busy day, to sit and create, is a great and much needed gift to oneself. So often others needs are put before our own, leaving feelings of exhaustion and emptiness behind by the day's end. Take time to create, even if it's only for fifteen minutes. Consider the time spent as a power nap, where you'll regenerate and renew your spirit, making life easier to bear while creating a willingness to face what needs to be.

Laugh a little,
Play a little,
Do this everyday!

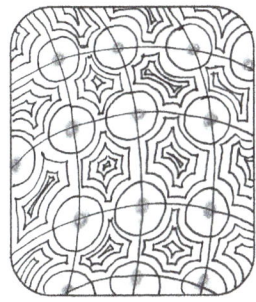

Think how a smile makes you feel. A smile is uplifting to your face, your heart, your spirit, and to the person you give it to, or who gave it to you.

Smiles are free, they cost us nothing, but give us much. Give a smile to everyone you meet and count the smiles you receive in return. It will make for a better day. What makes you smile?

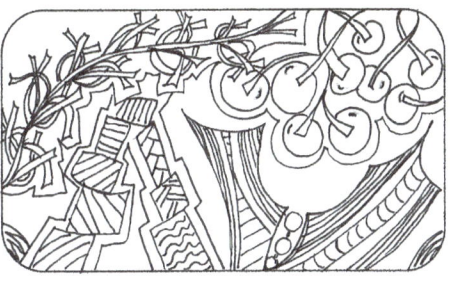 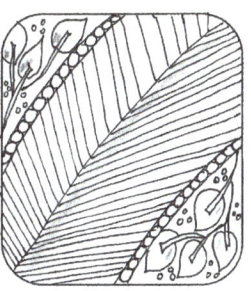

If you have a weakness, make it work for you as a strength. I tangle to renew my inner spirit, to relax, and to bring about satisfaction in creating a piece of art. Whether I work on a tile (paper), fabric, ceramic, or tangle on my wheel barrow, I feel renewed, focused, and there's a greater sense of well-being when I'm finished. Take time to create, it's well worth the effort.

Remember...

*There are no Mistakes,
Only Possibilities!*

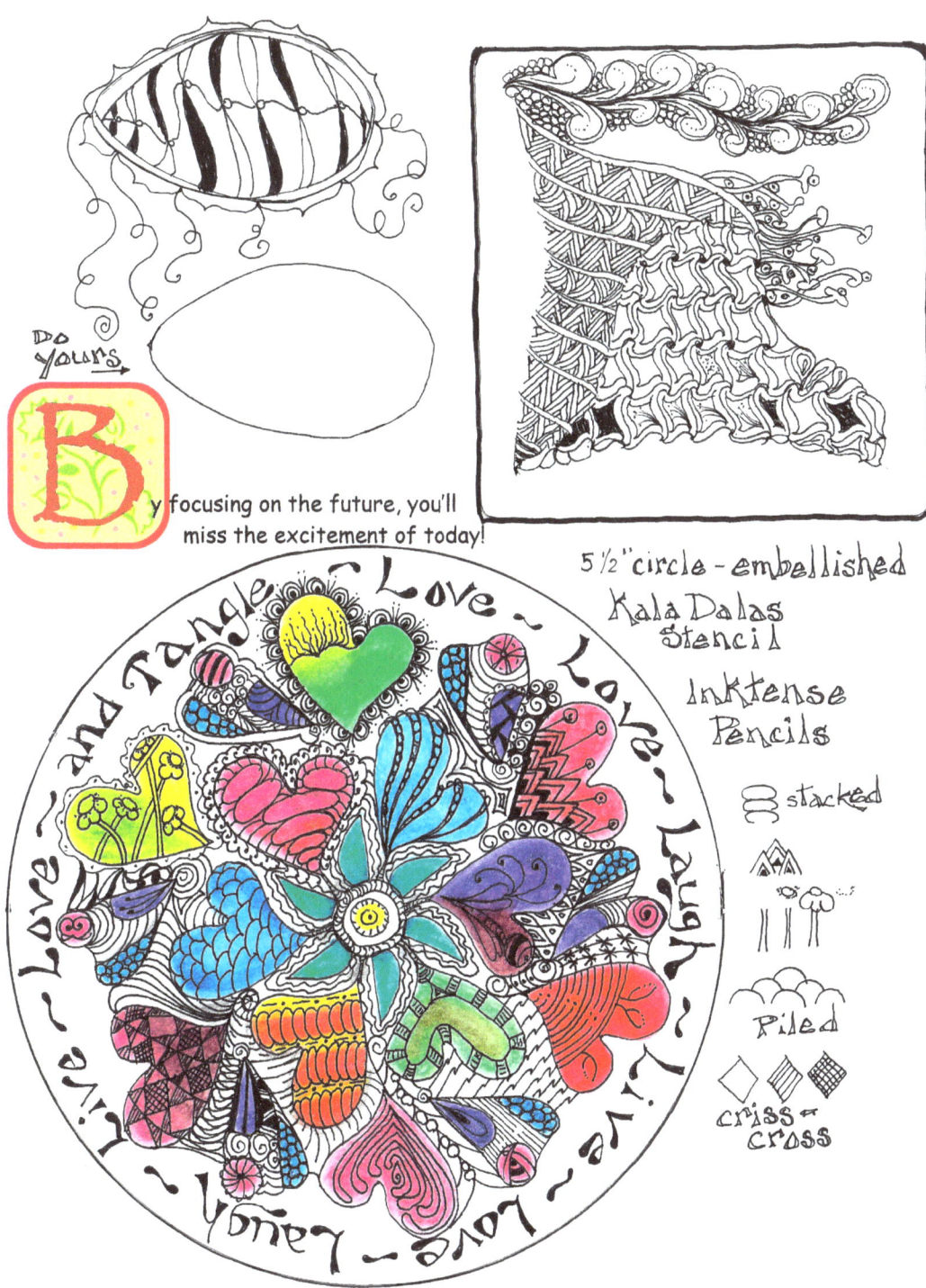

Do yours →

By focusing on the future, you'll miss the excitement of today!

5 ½" circle - embellished
Kala Dalas Stencil
Inktense Pencils

stacked

Piled

criss-cross

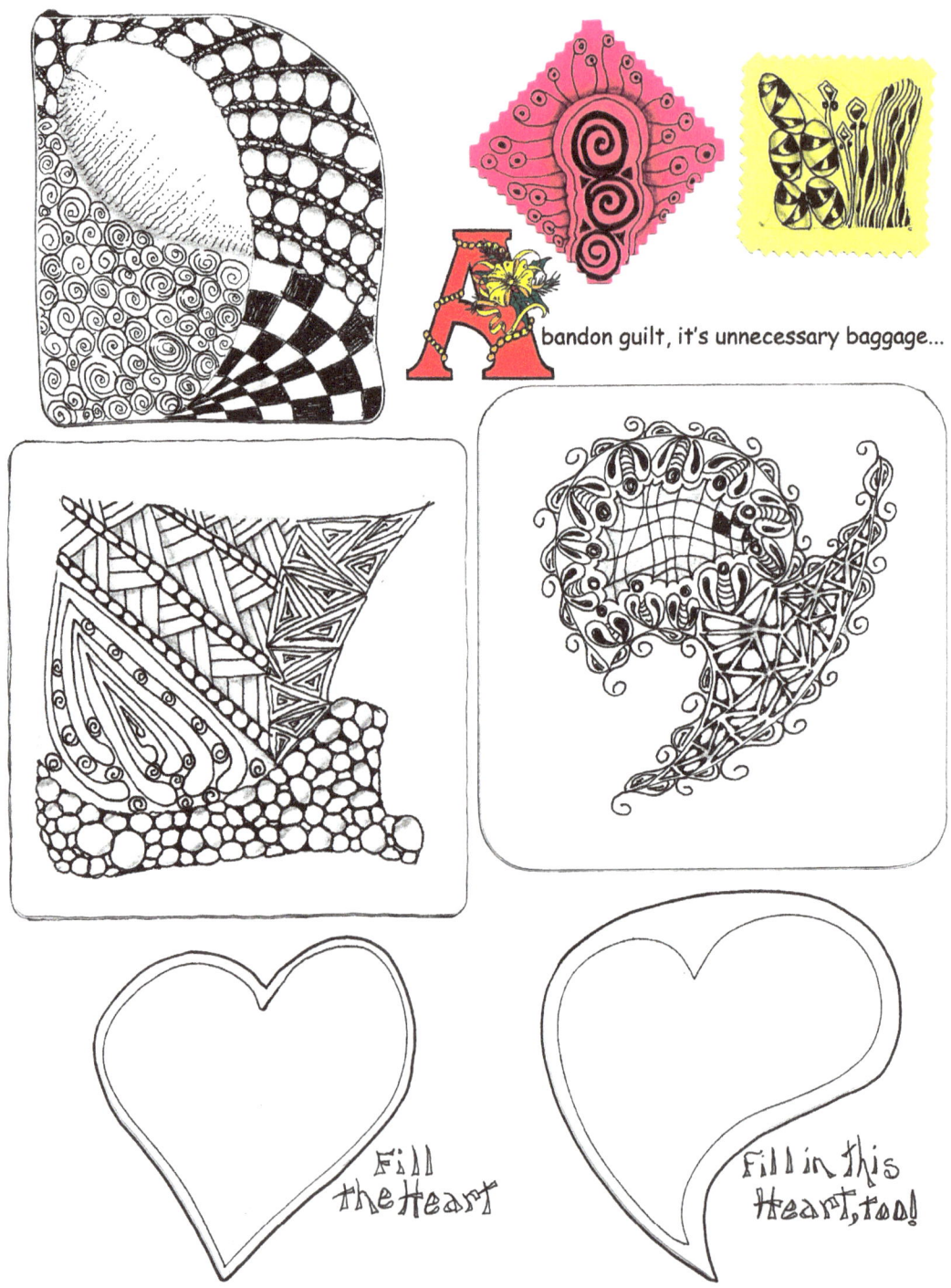

bandon guilt, it's unnecessary baggage...

Fill the Heart

Fill in this Heart, too!

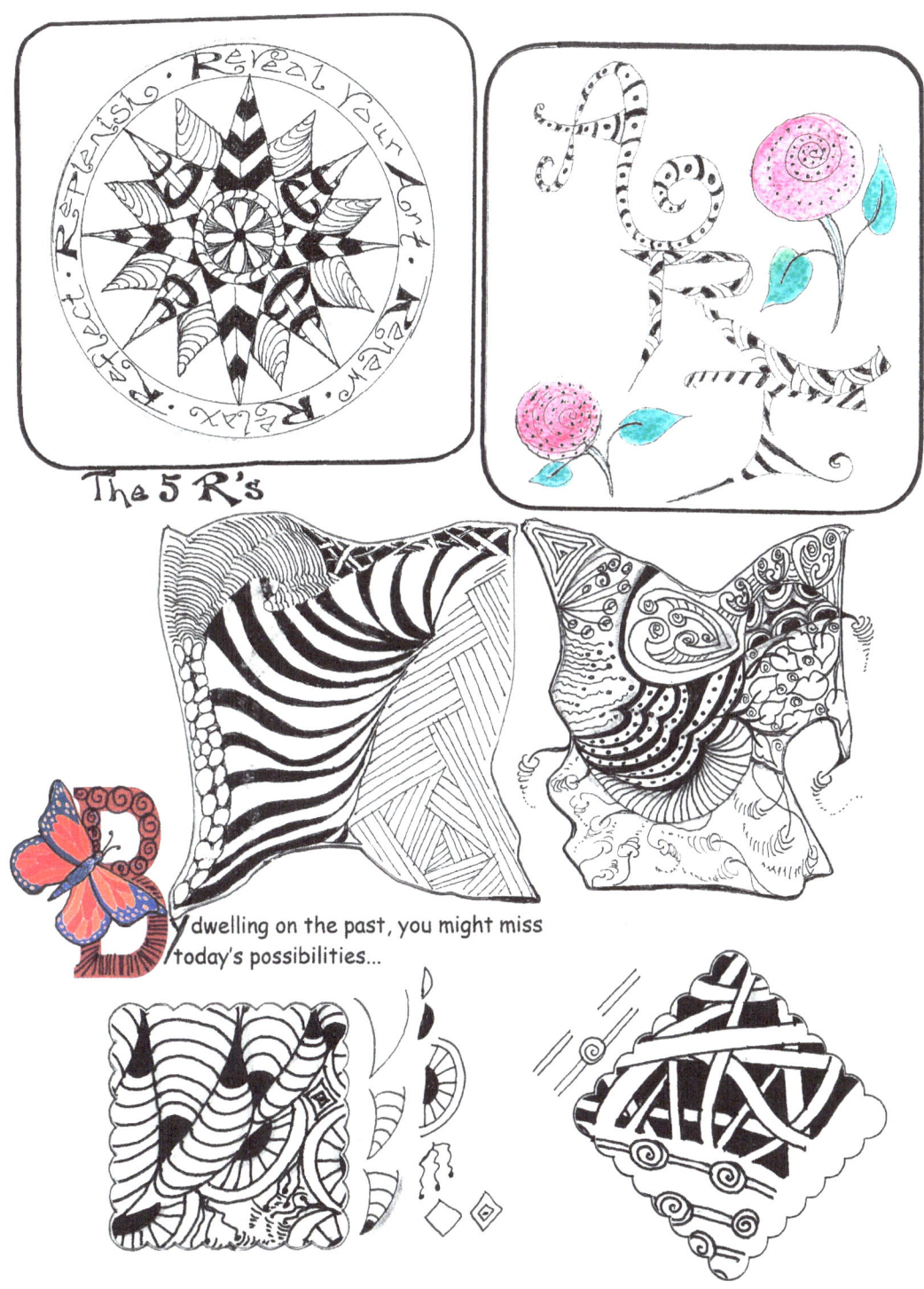

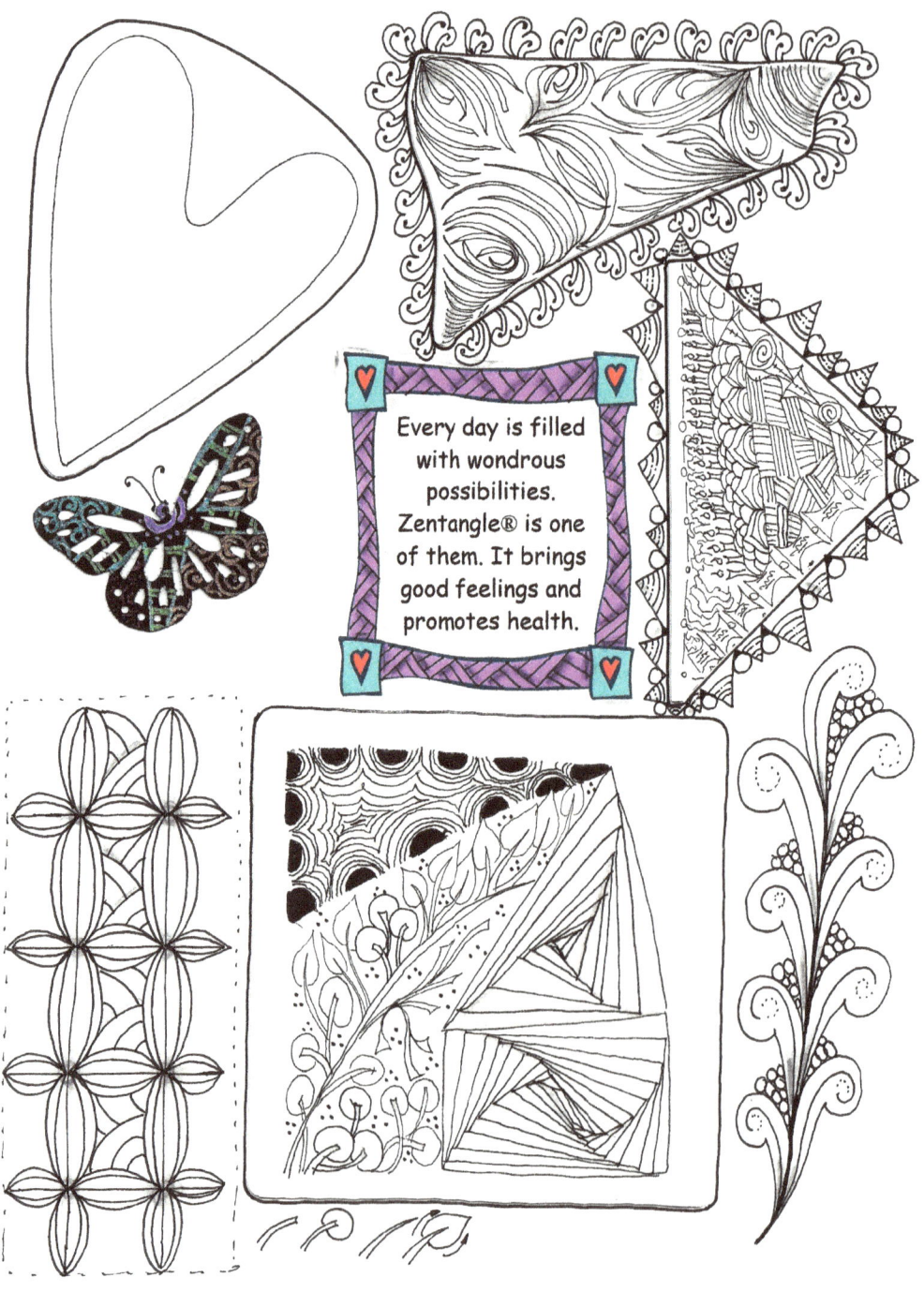

Every day is filled with wondrous possibilities. Zentangle® is one of them. It brings good feelings and promotes health.

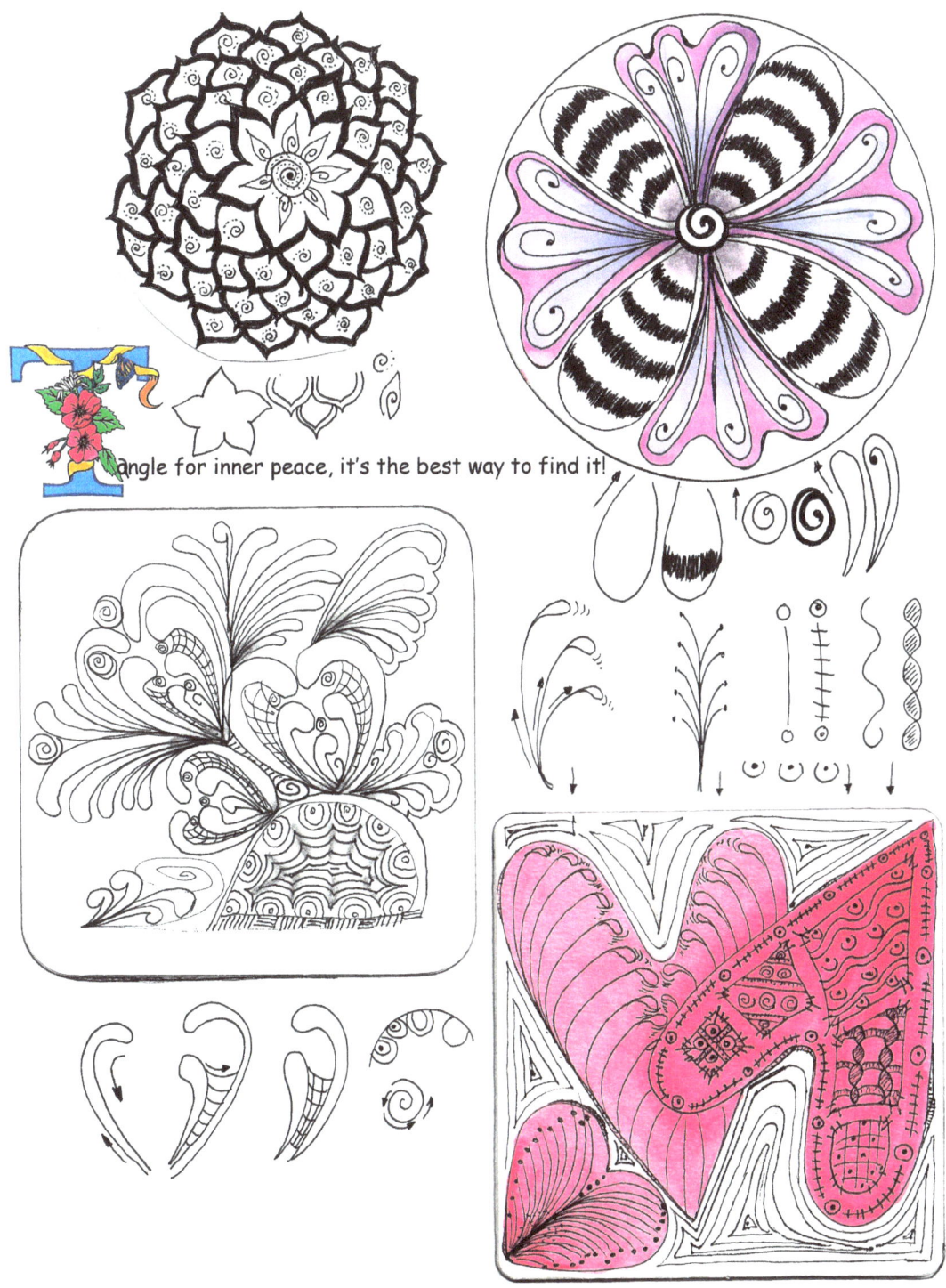

angle for inner peace, it's the best way to find it!

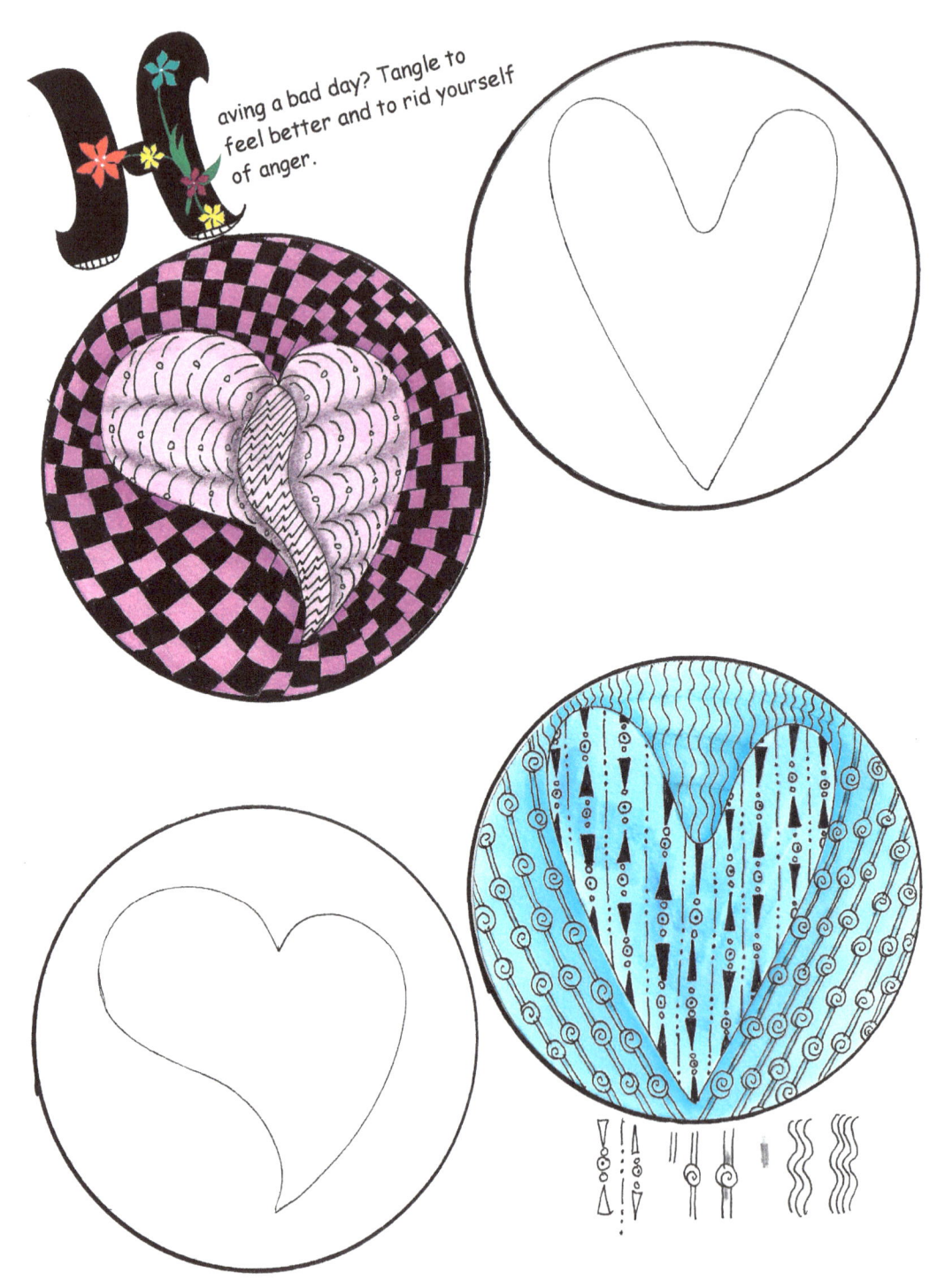

Having a bad day? Tangle to feel better and to rid yourself of anger.

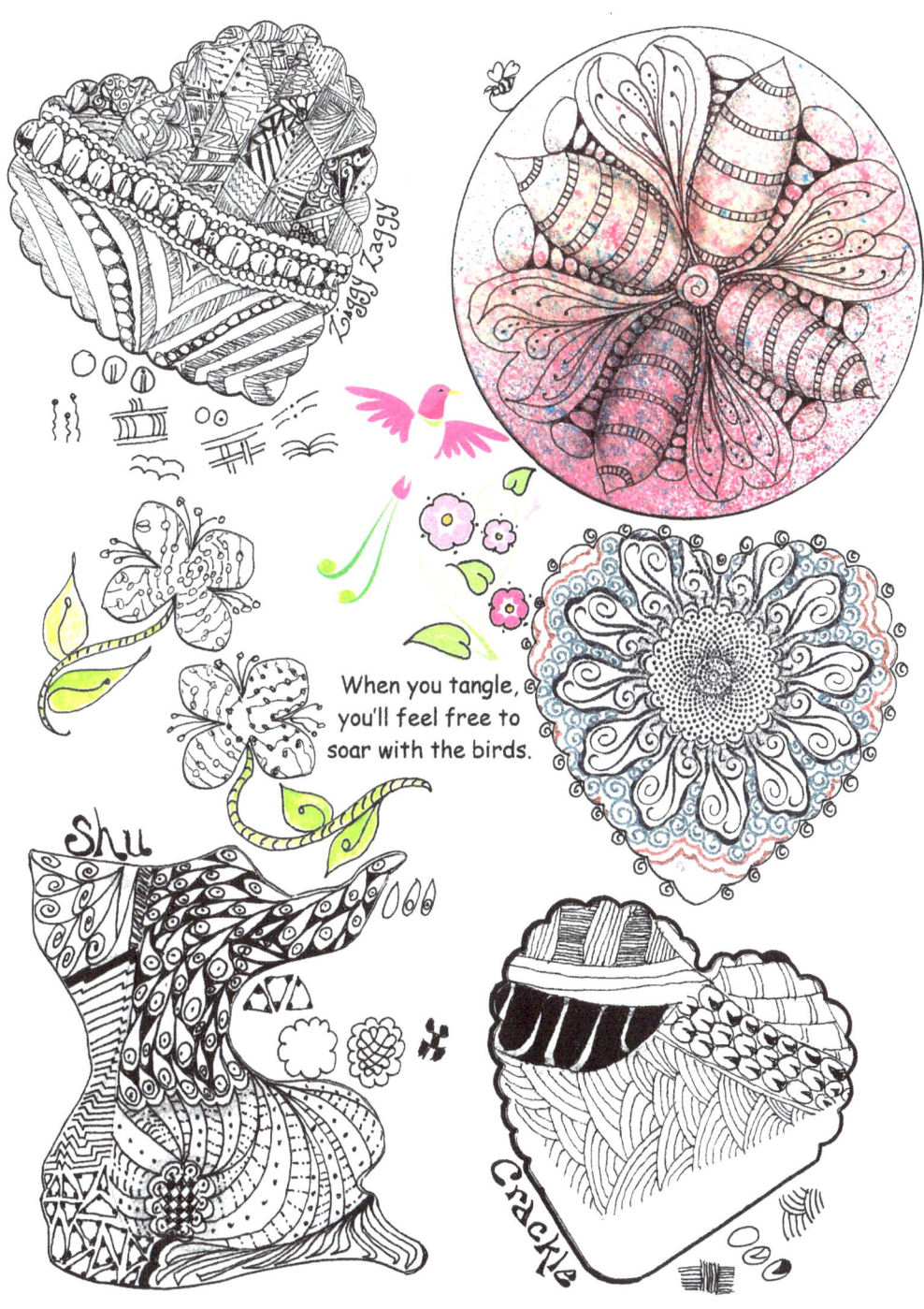

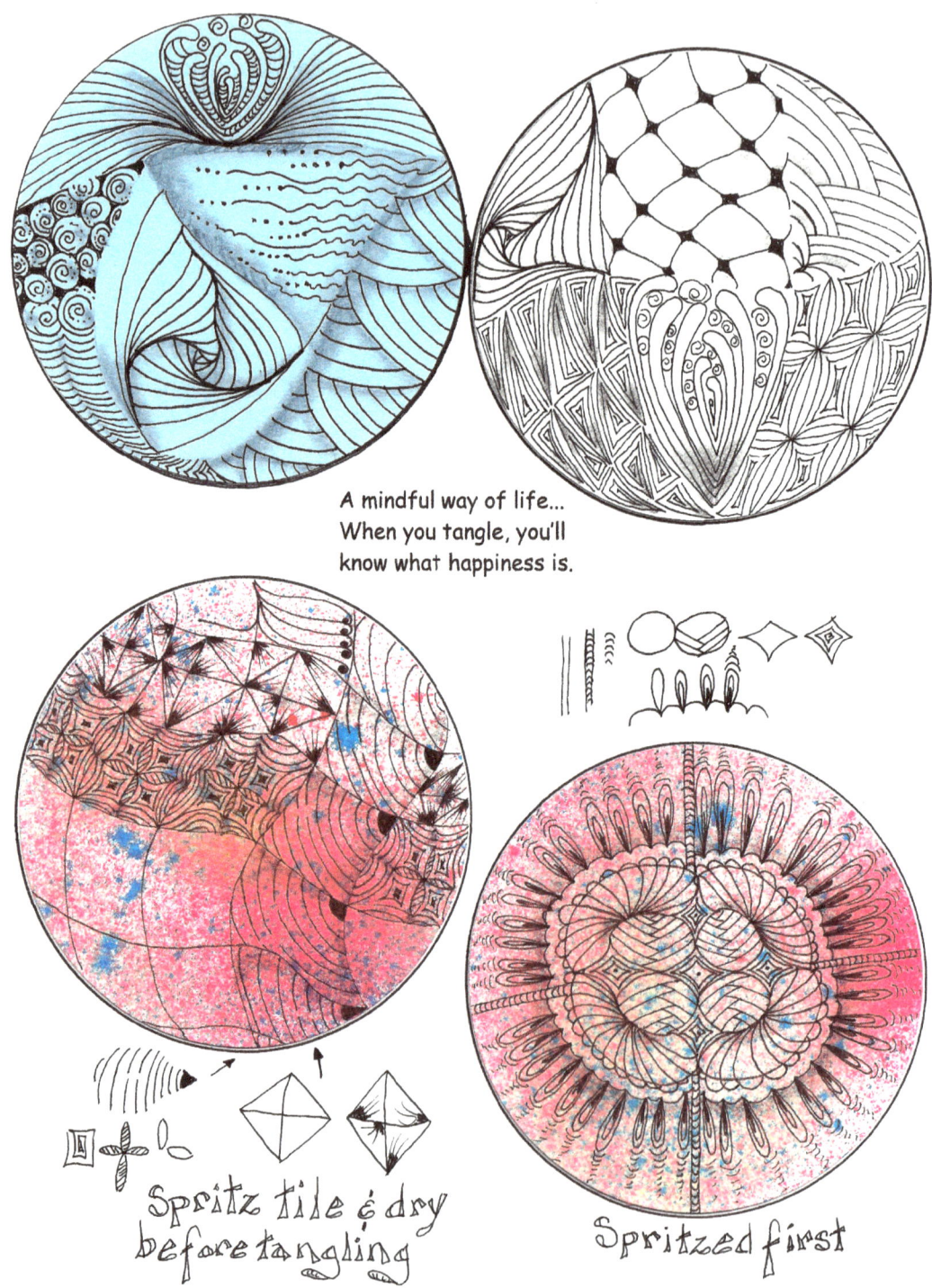

A mindful way of life...
When you tangle, you'll know what happiness is.

Spritz tile & dry before tangling

Spritzed first

Surrender your mind and refresh your spirit with Zentangle®. Tangle daily to create a new experience.

 Is for Zentangle®

 Is for tangling!

 Is for Opportunities!

 Is for energy!

Learn more about Zentangle®, take a class from a certified Zentangle instructor (CZT)
There is much more to the art of tangling than merely creating art.
For a list of certified instructors, visit www.zentangle.com

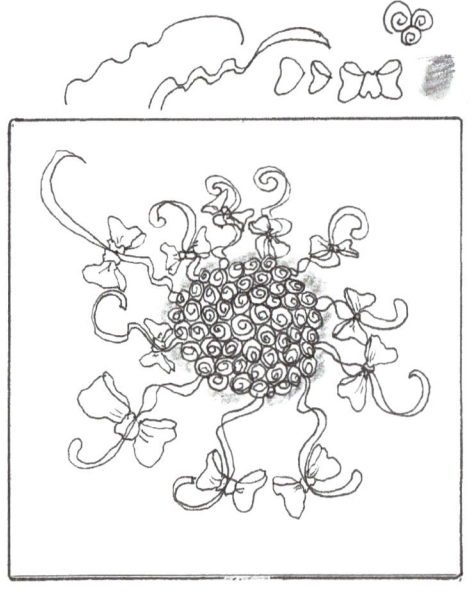

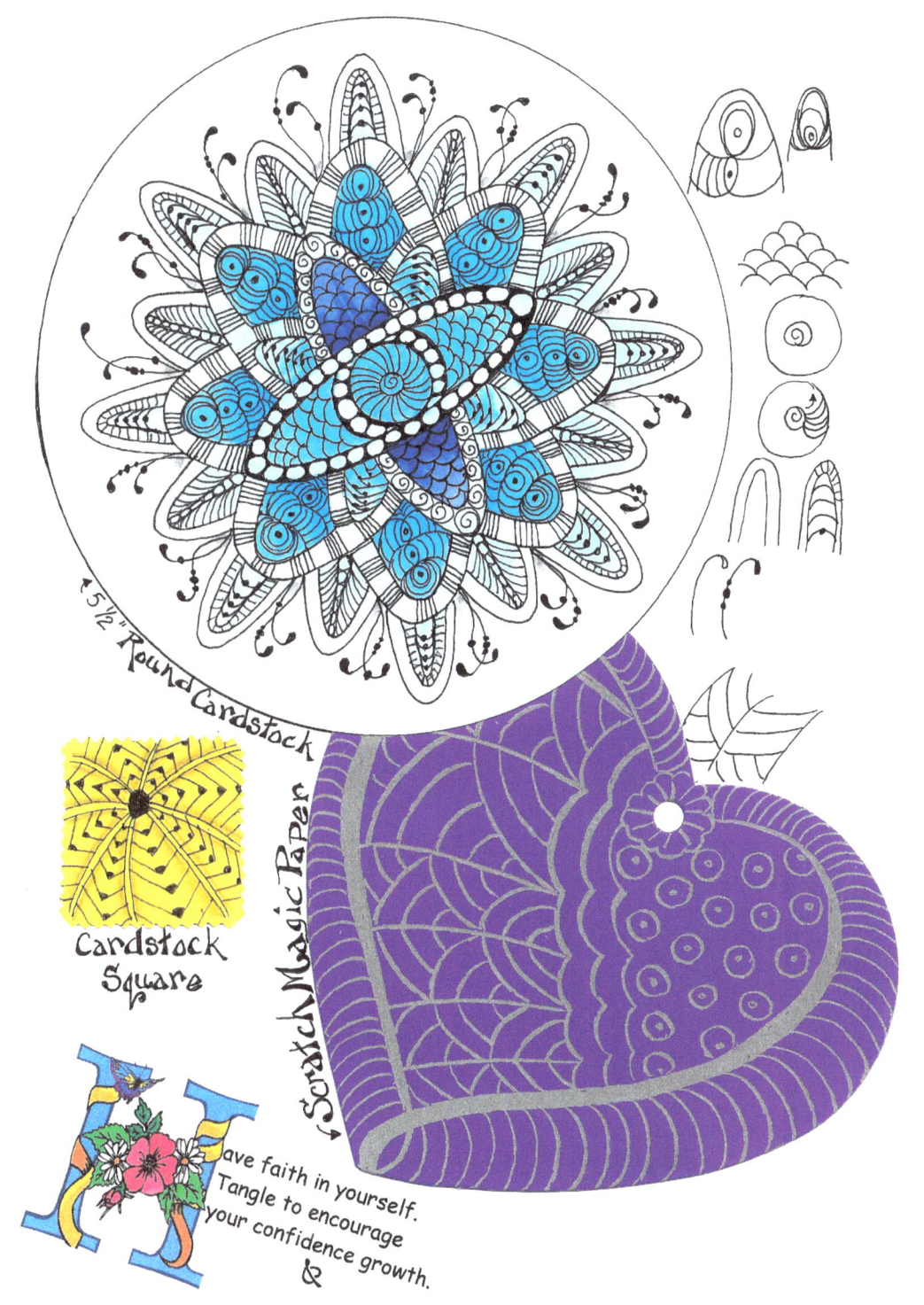

With Zentangle®, I am free to enjoy my finest work.

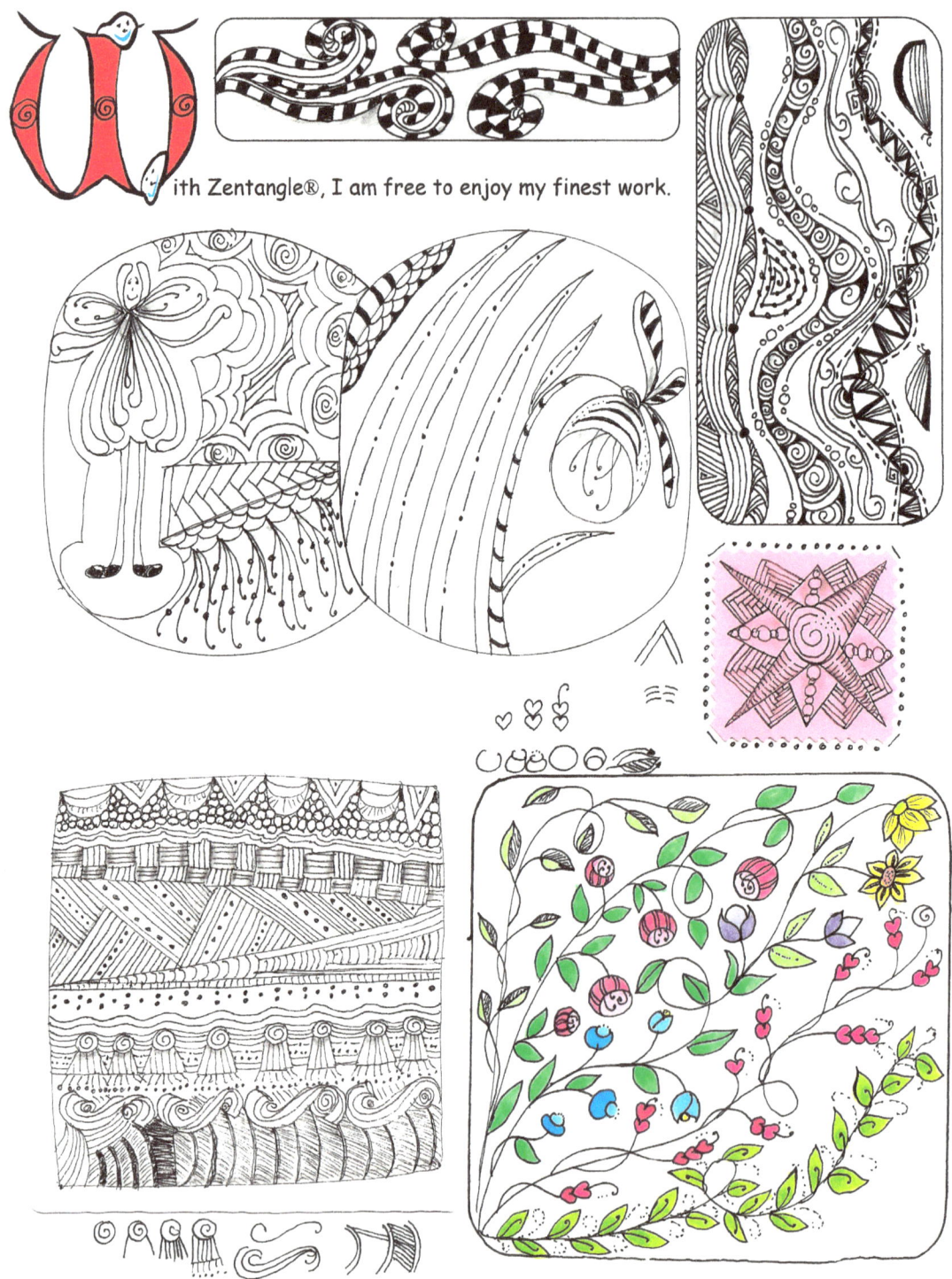

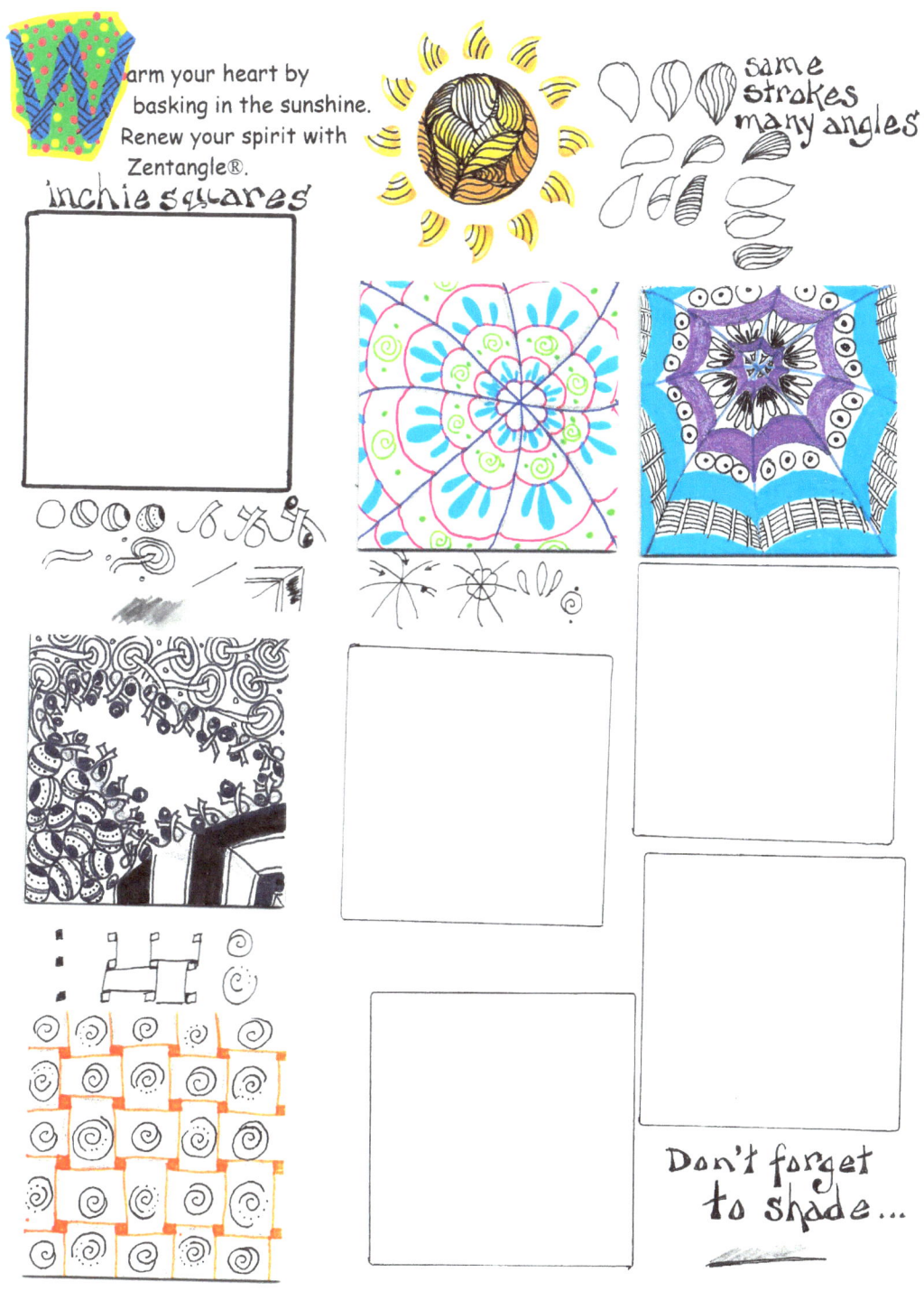

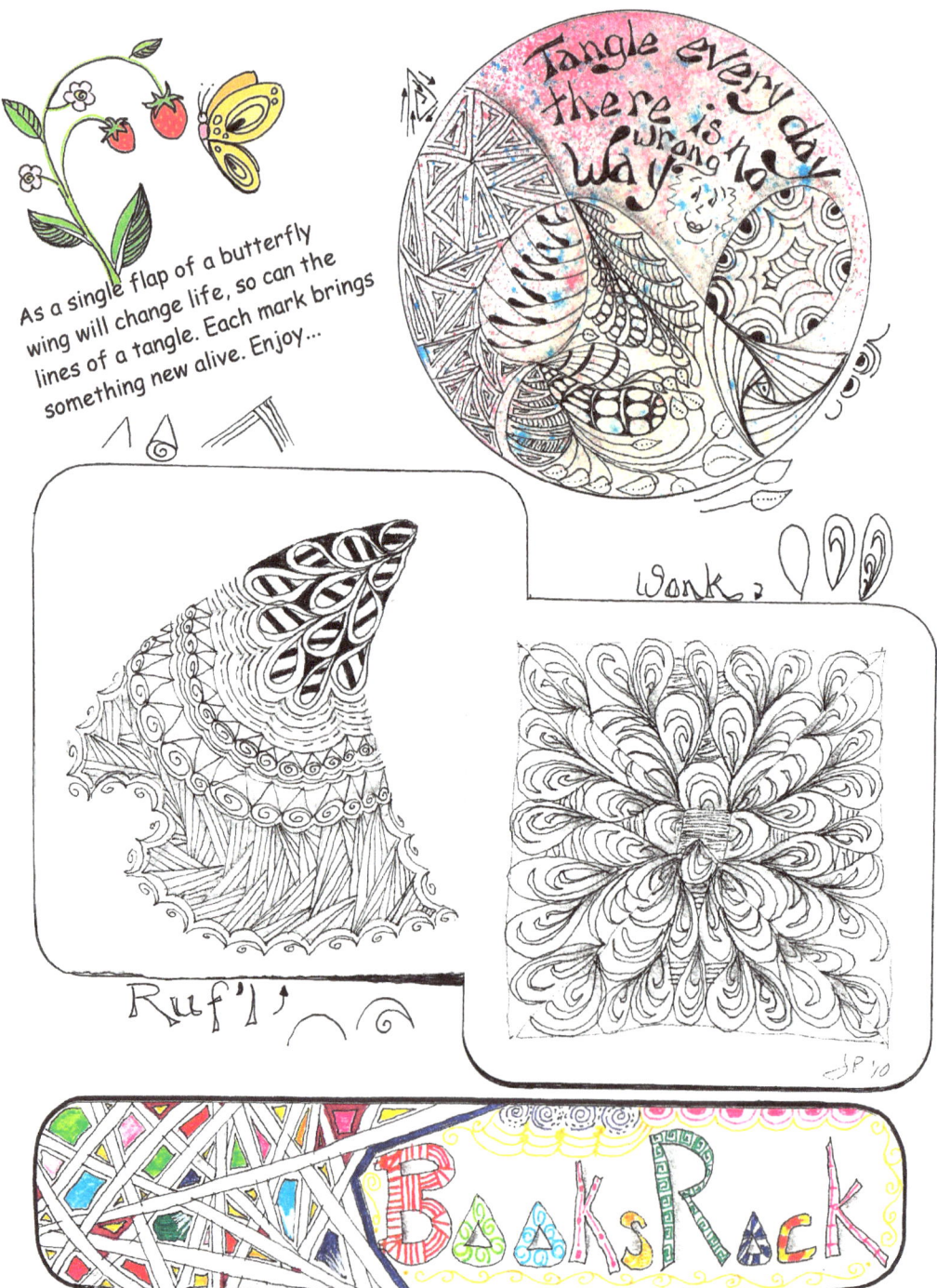

Black on white allows easy creation of a tangle.
Having to decide on a color palette takes more thought.

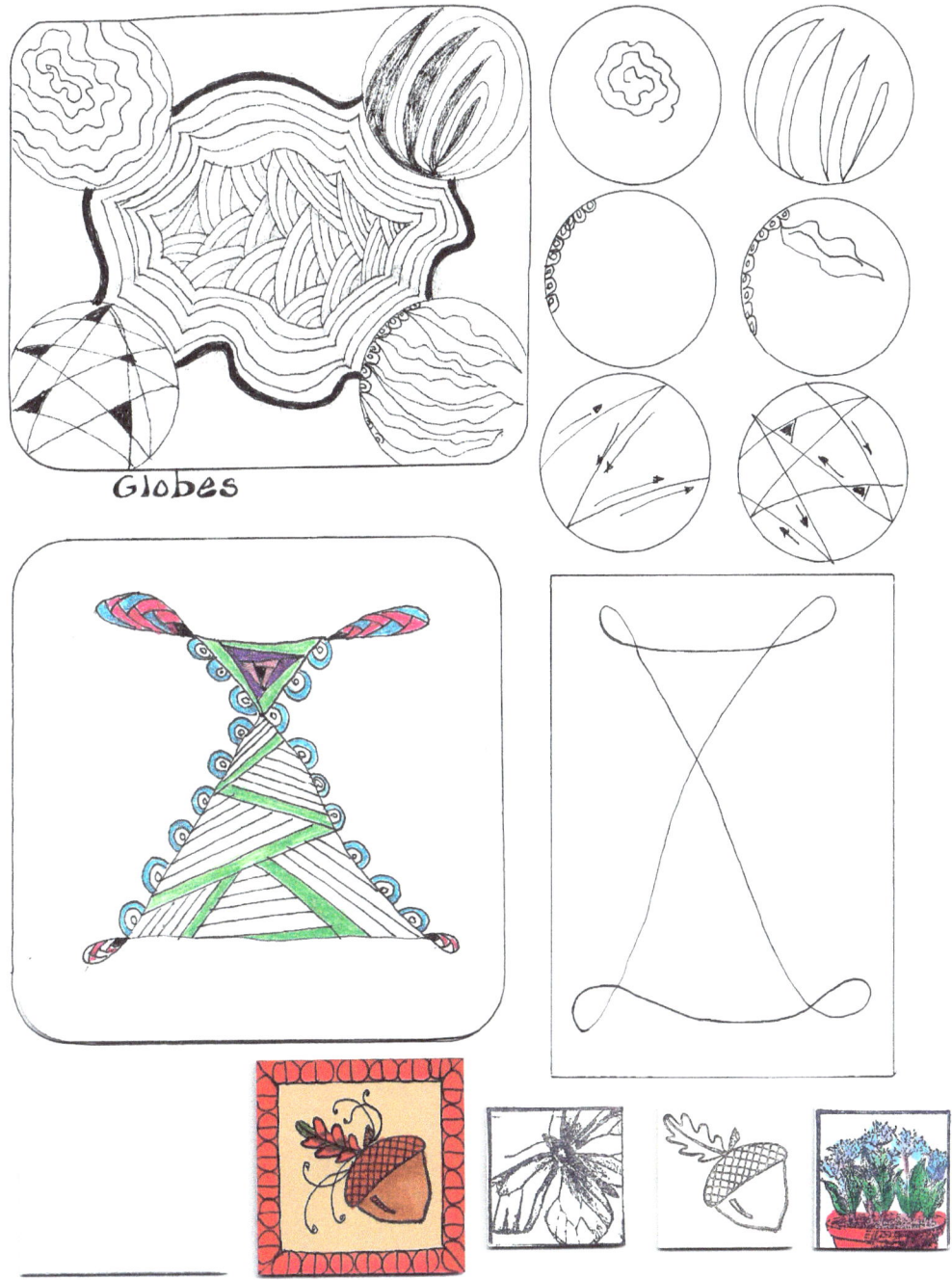

Globes

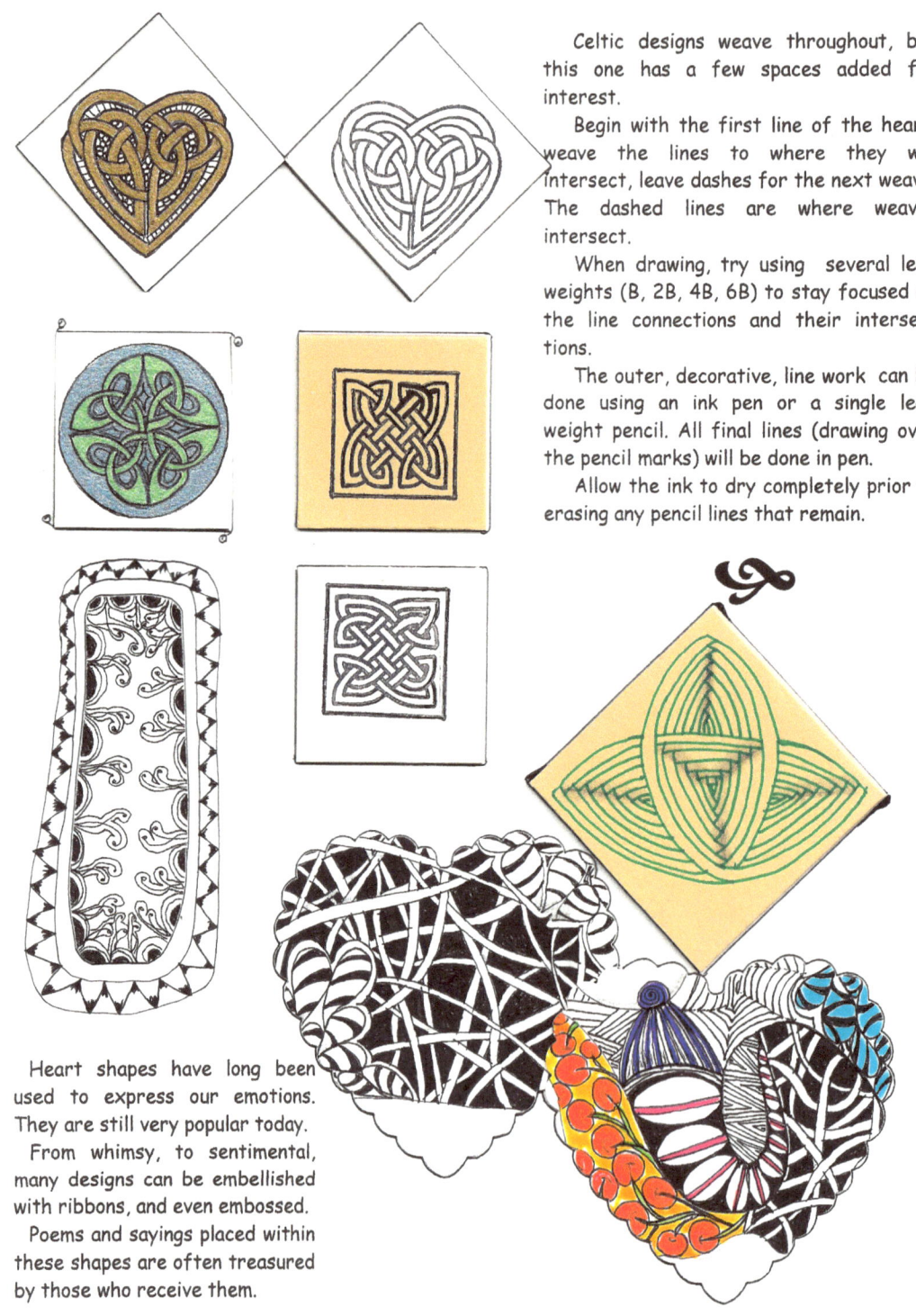

Celtic designs weave throughout, but this one has a few spaces added for interest.

Begin with the first line of the heart, weave the lines to where they will intersect, leave dashes for the next weave. The dashed lines are where weaves intersect.

When drawing, try using several lead weights (B, 2B, 4B, 6B) to stay focused on the line connections and their intersections.

The outer, decorative, line work can be done using an ink pen or a single lead weight pencil. All final lines (drawing over the pencil marks) will be done in pen.

Allow the ink to dry completely prior to erasing any pencil lines that remain.

Heart shapes have long been used to express our emotions. They are still very popular today.

From whimsy, to sentimental, many designs can be embellished with ribbons, and even embossed.

Poems and sayings placed within these shapes are often treasured by those who receive them.

Taking time to tangle is a gift you give yourself.

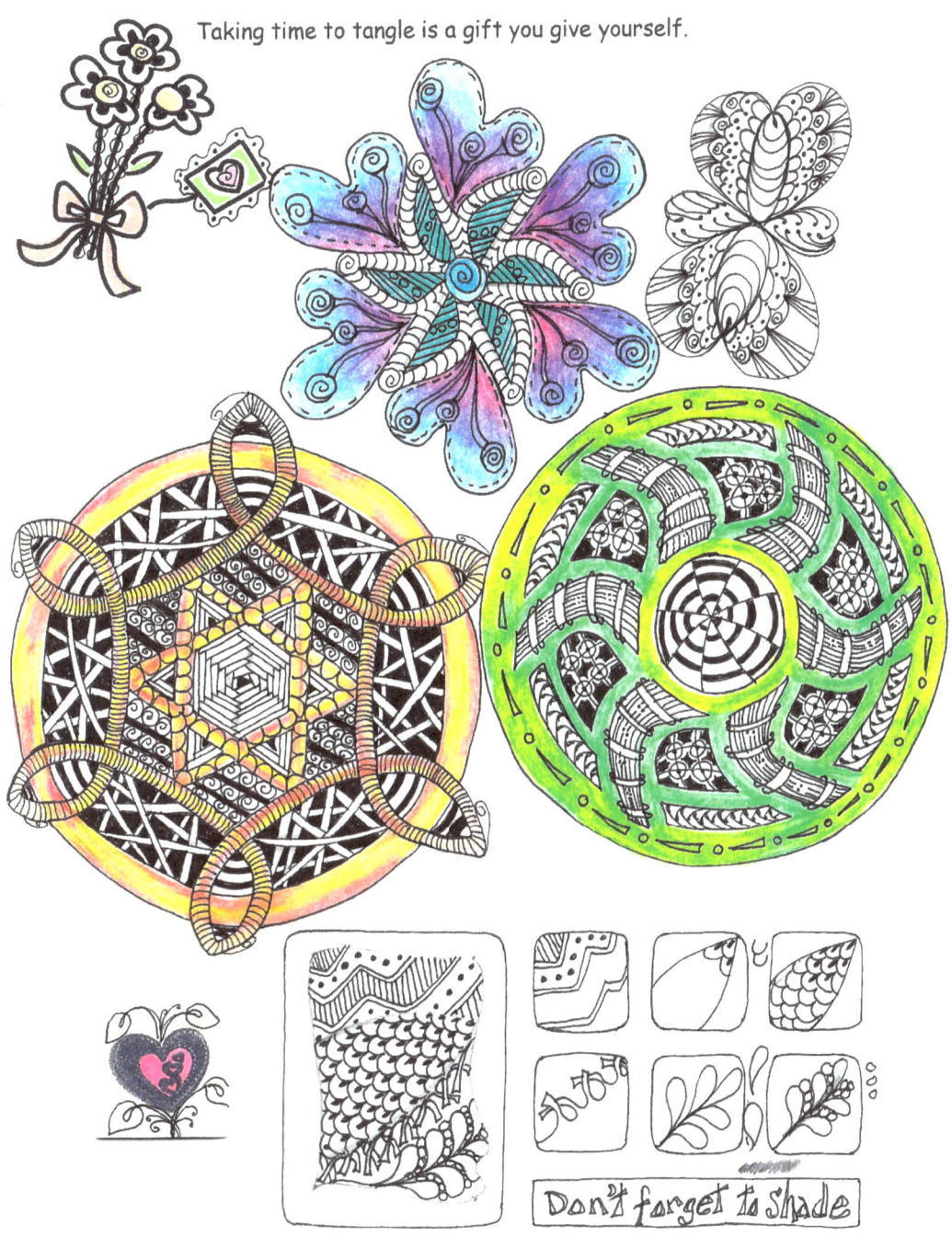

Don't forget to shade

Zentangle® is a form of repetitive art designed to assist in relaxation, creation, focus, confidence building, and much, much more.

There are teachers worldwide, blogs and groups have formed to help each of us grow. There is also the official Zentangle® website that can be found at:

www.zentangle.com

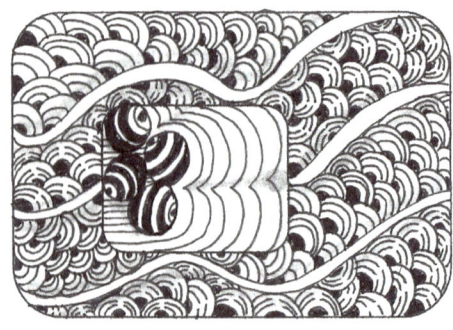

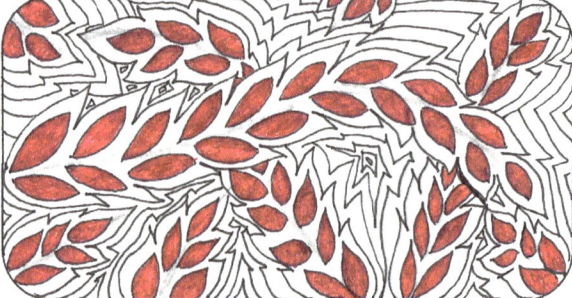

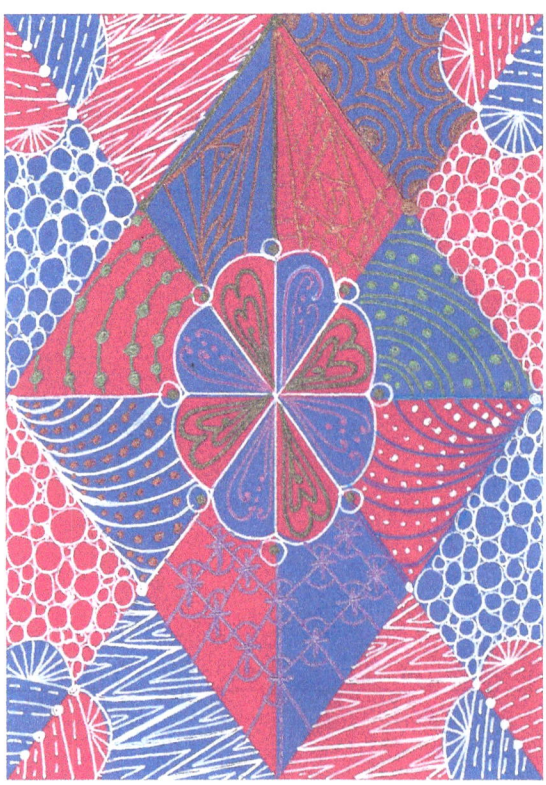

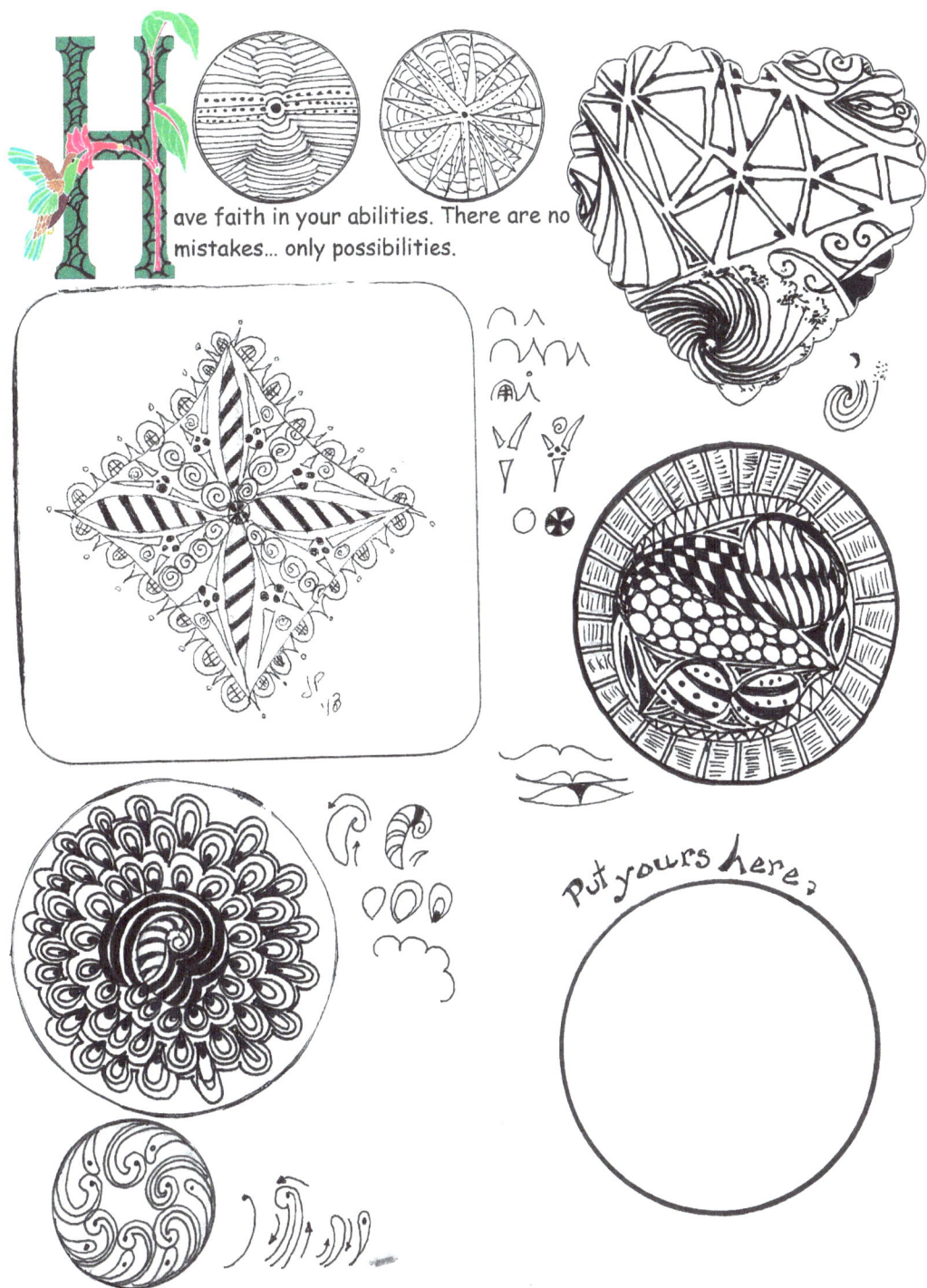

Have faith in your abilities. There are no mistakes... only possibilities.

I fill my tangles with unquenchable happiness and joy!
What are your tangles filled with?

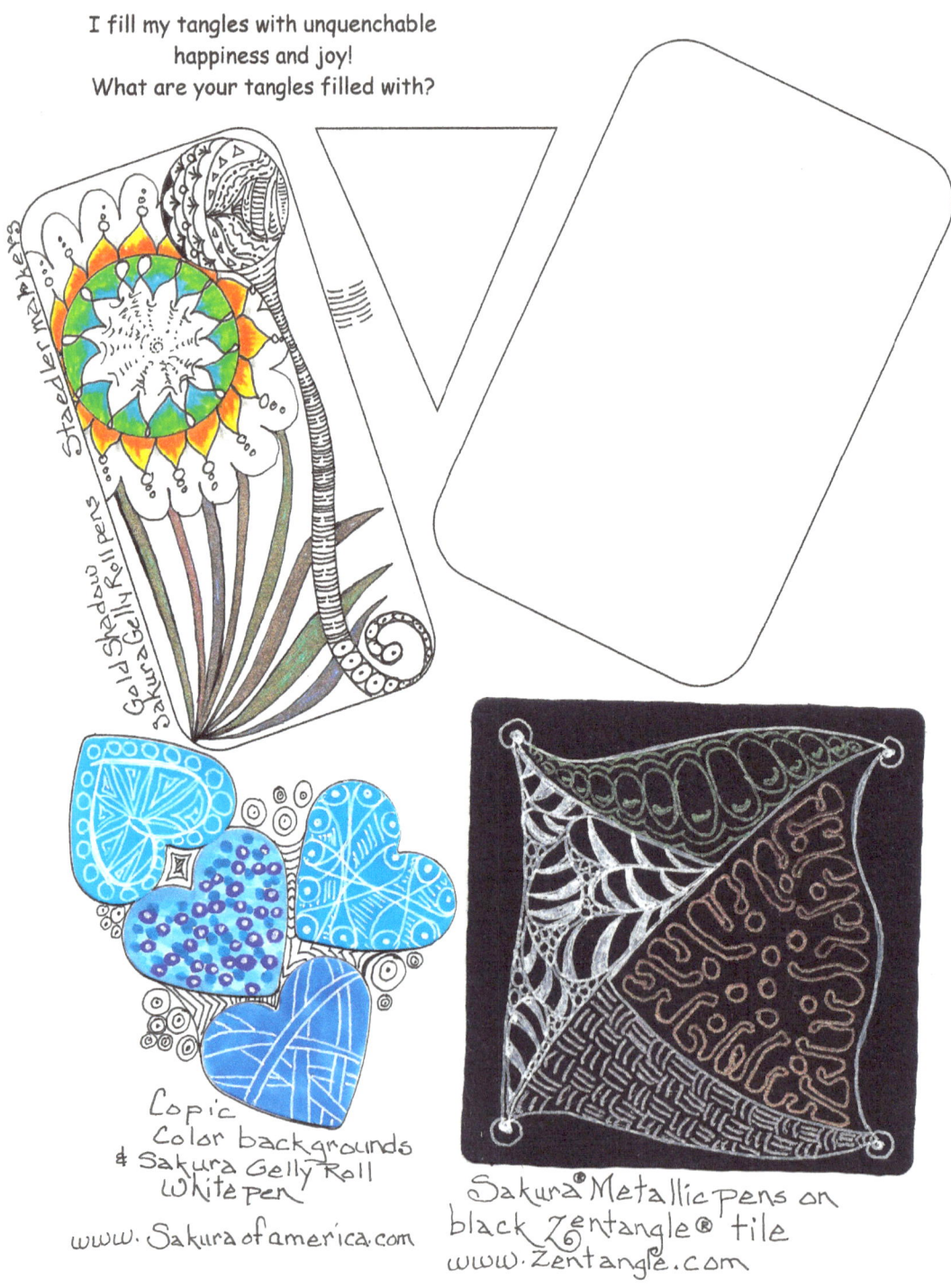

There is much enrichment of life in a tangled garden.

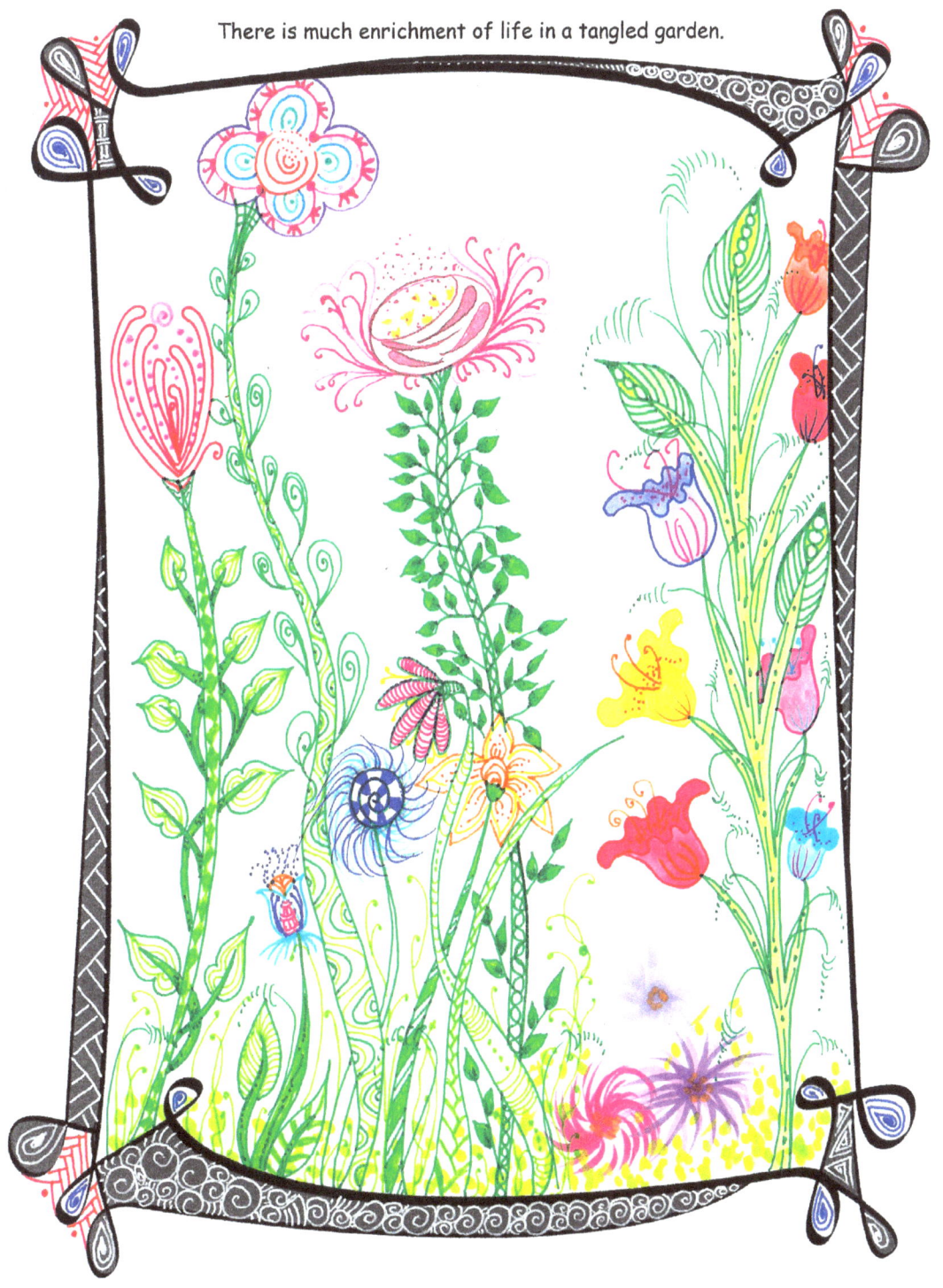

 egardless of age or circumstances, the art of tangling can always be enriching. Take control of life and reflect on your inner self.

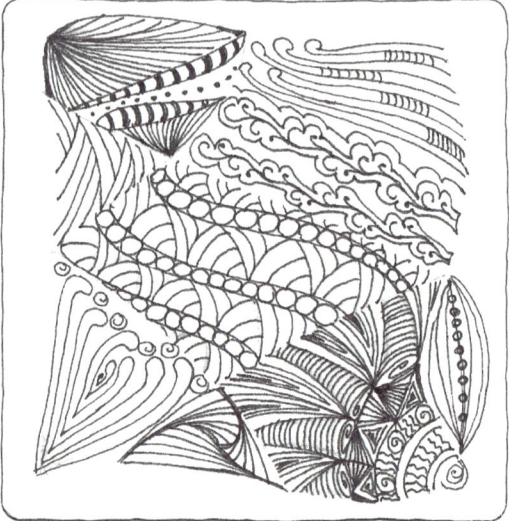
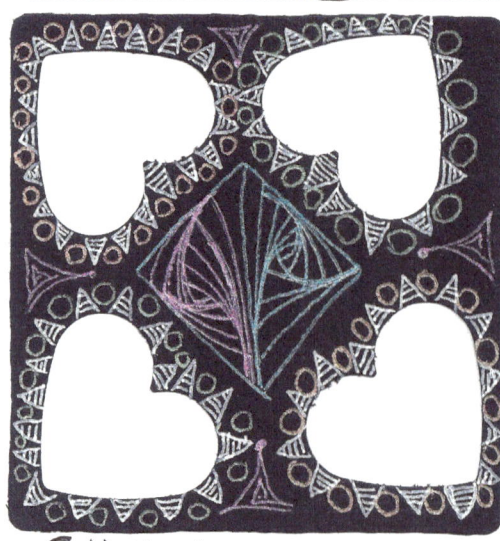

Fill the hearts

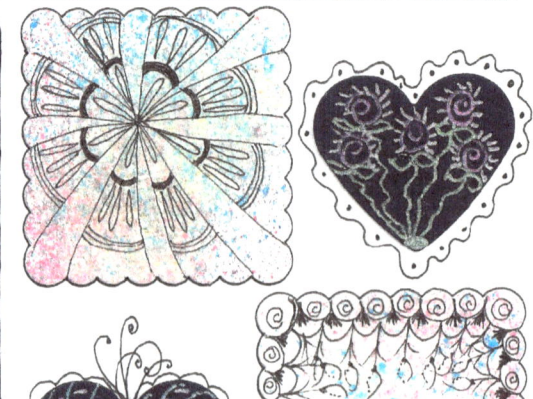

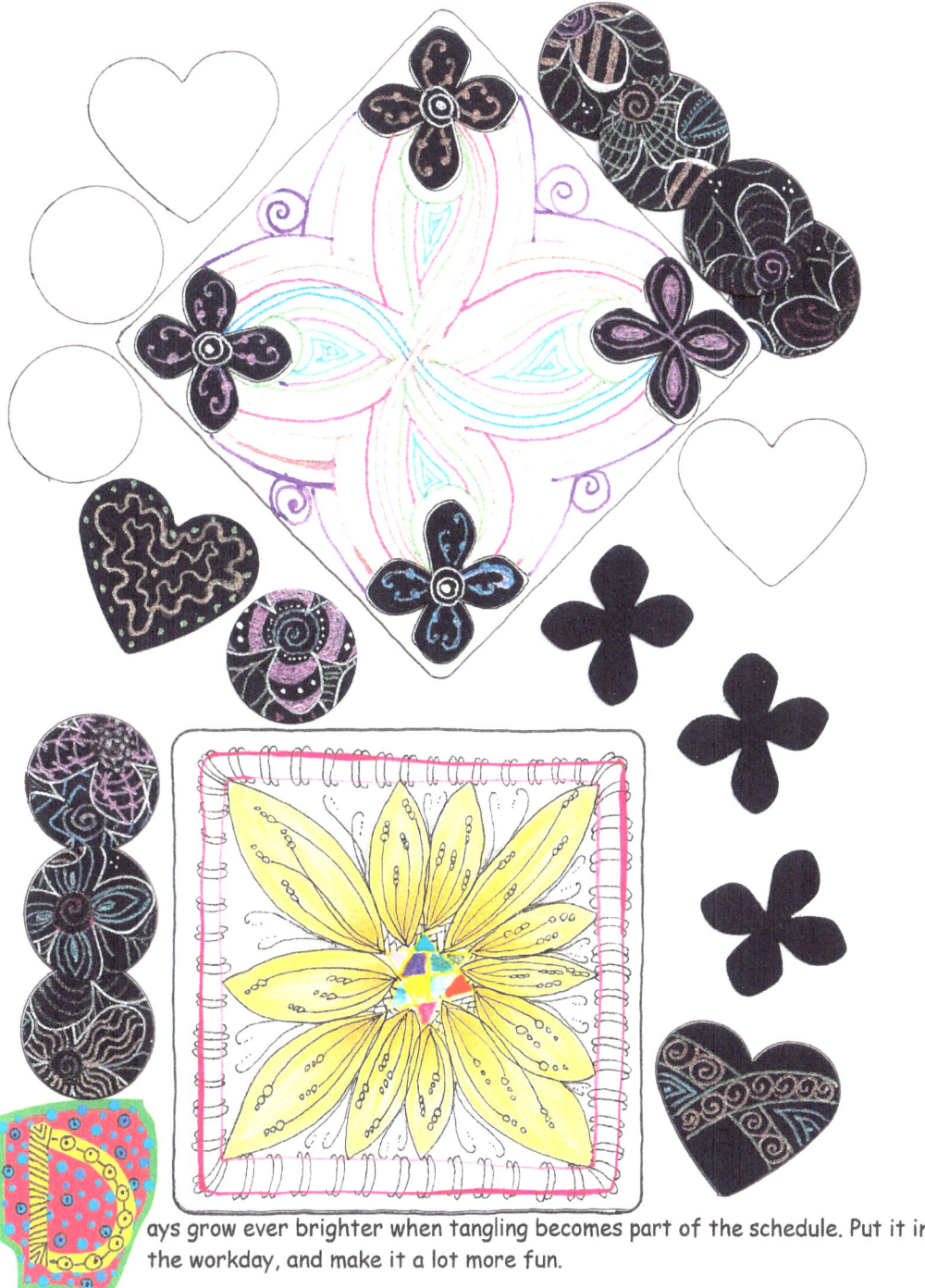

Days grow ever brighter when tangling becomes part of the schedule. Put it in the workday, and make it a lot more fun.

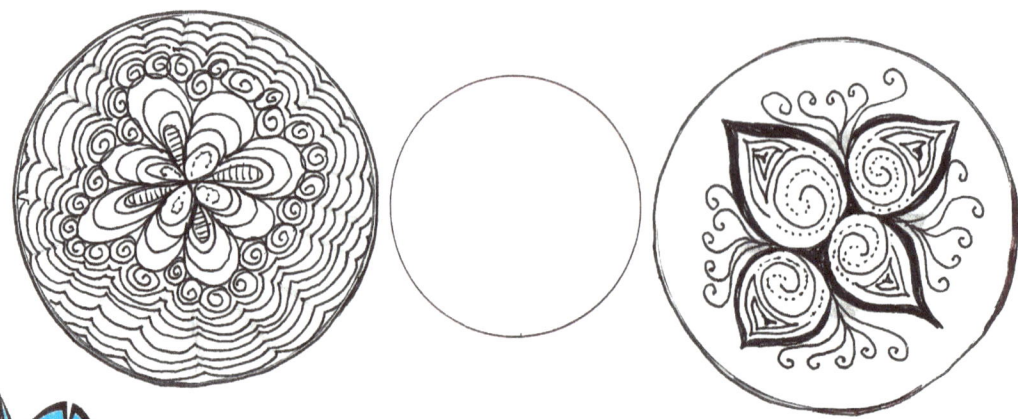

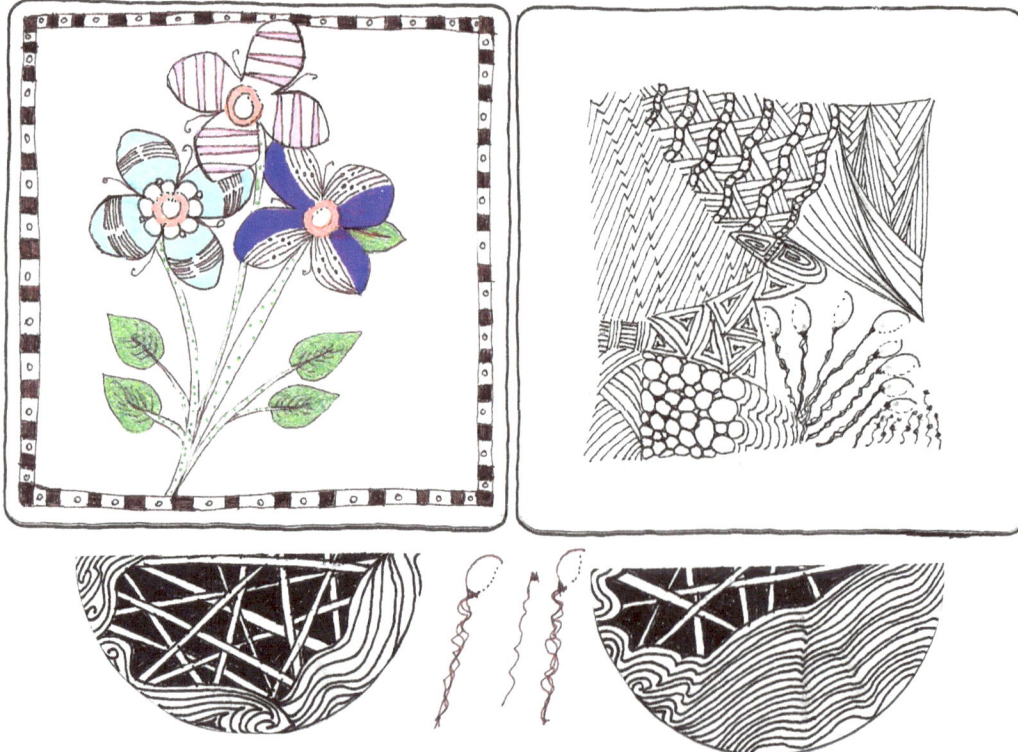

No matter what situations may arise throughout the day, use the art of tangling to lessen anxiety and fear of the unknown. Take the challenge of tangling daily to create a more peaceful lifestyle.

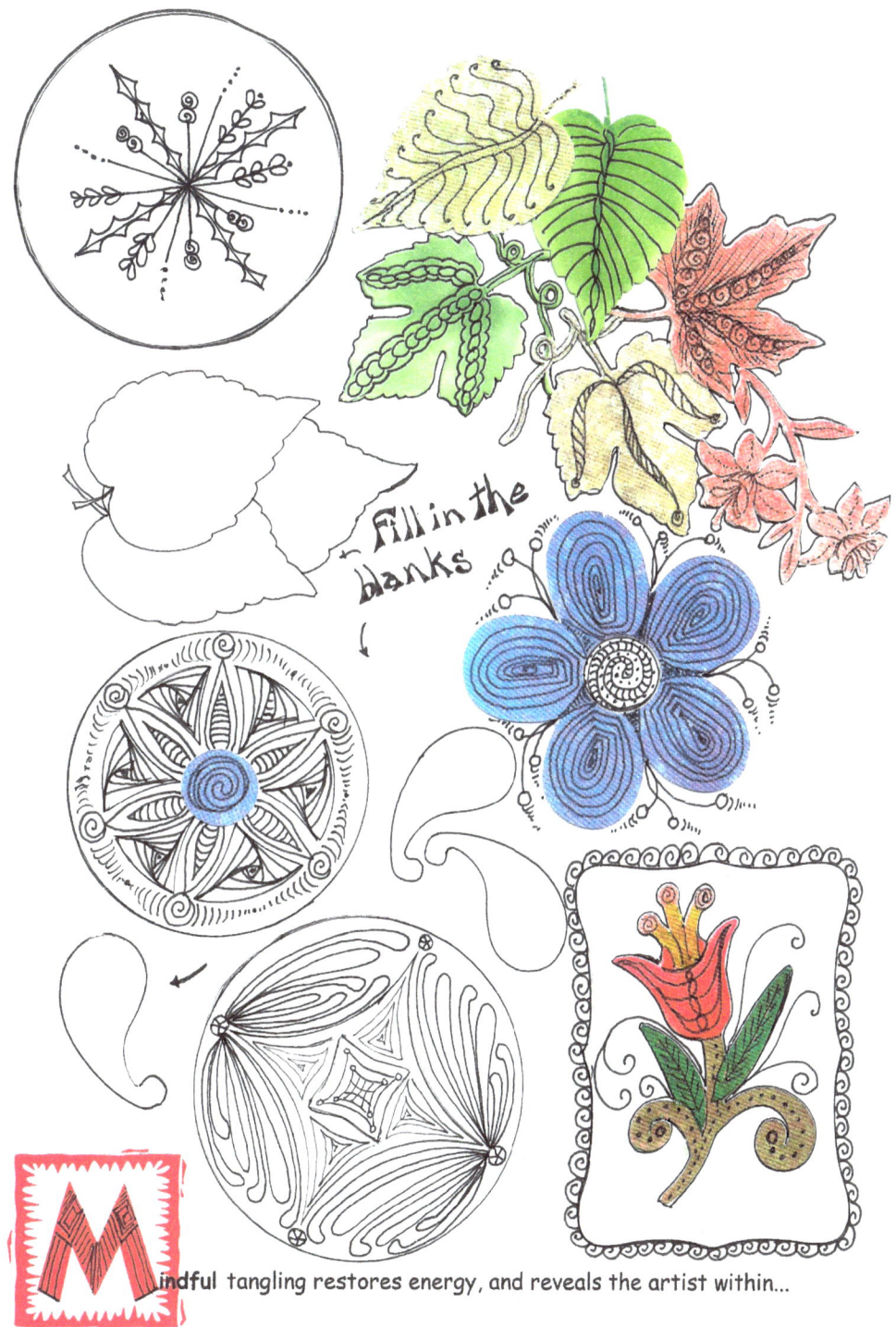

Mindful tangling restores energy, and reveals the artist within...

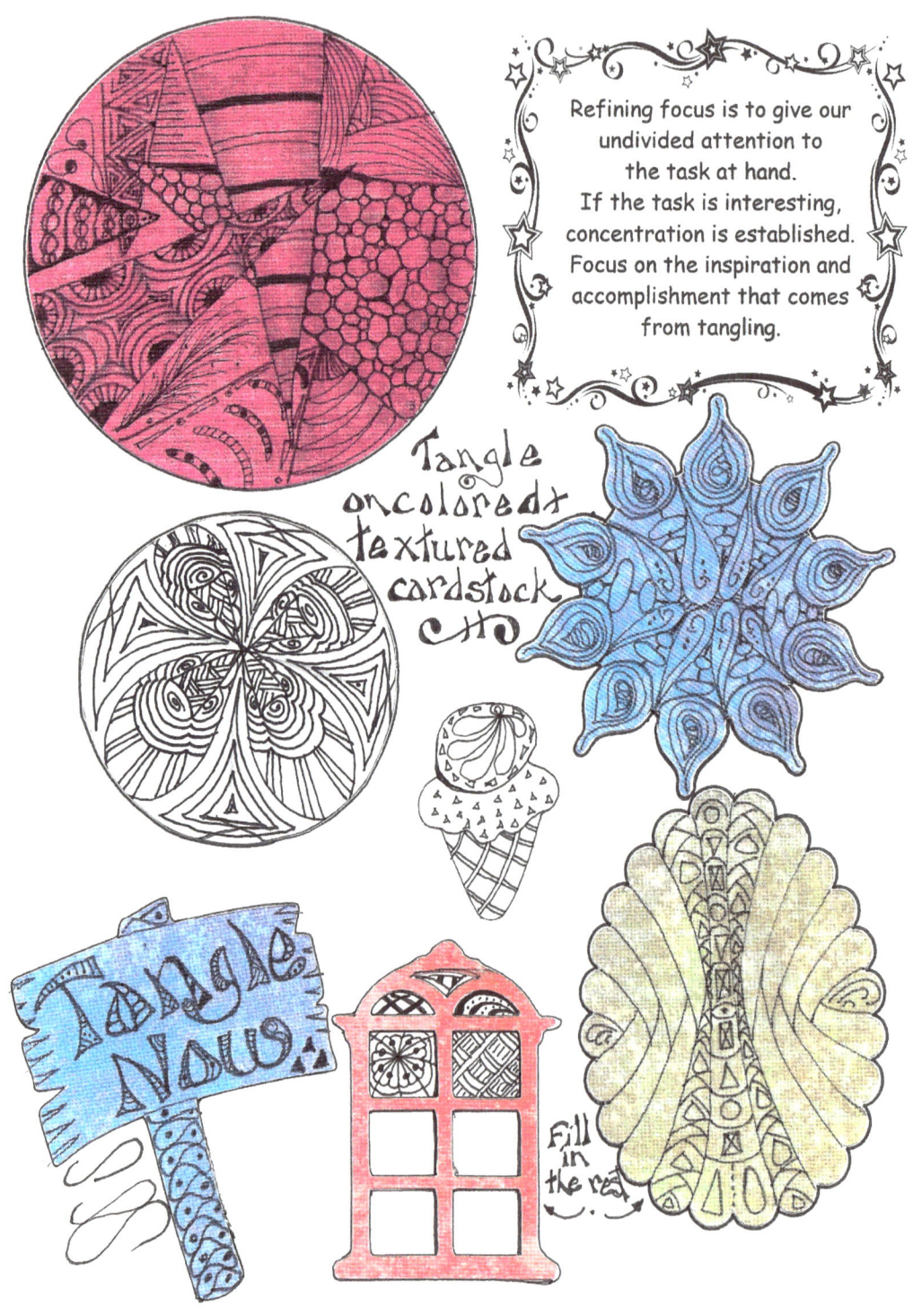

Refining focus is to give our undivided attention to the task at hand. If the task is interesting, concentration is established. Focus on the inspiration and accomplishment that comes from tangling.

Tangle on colored + textured cardstock

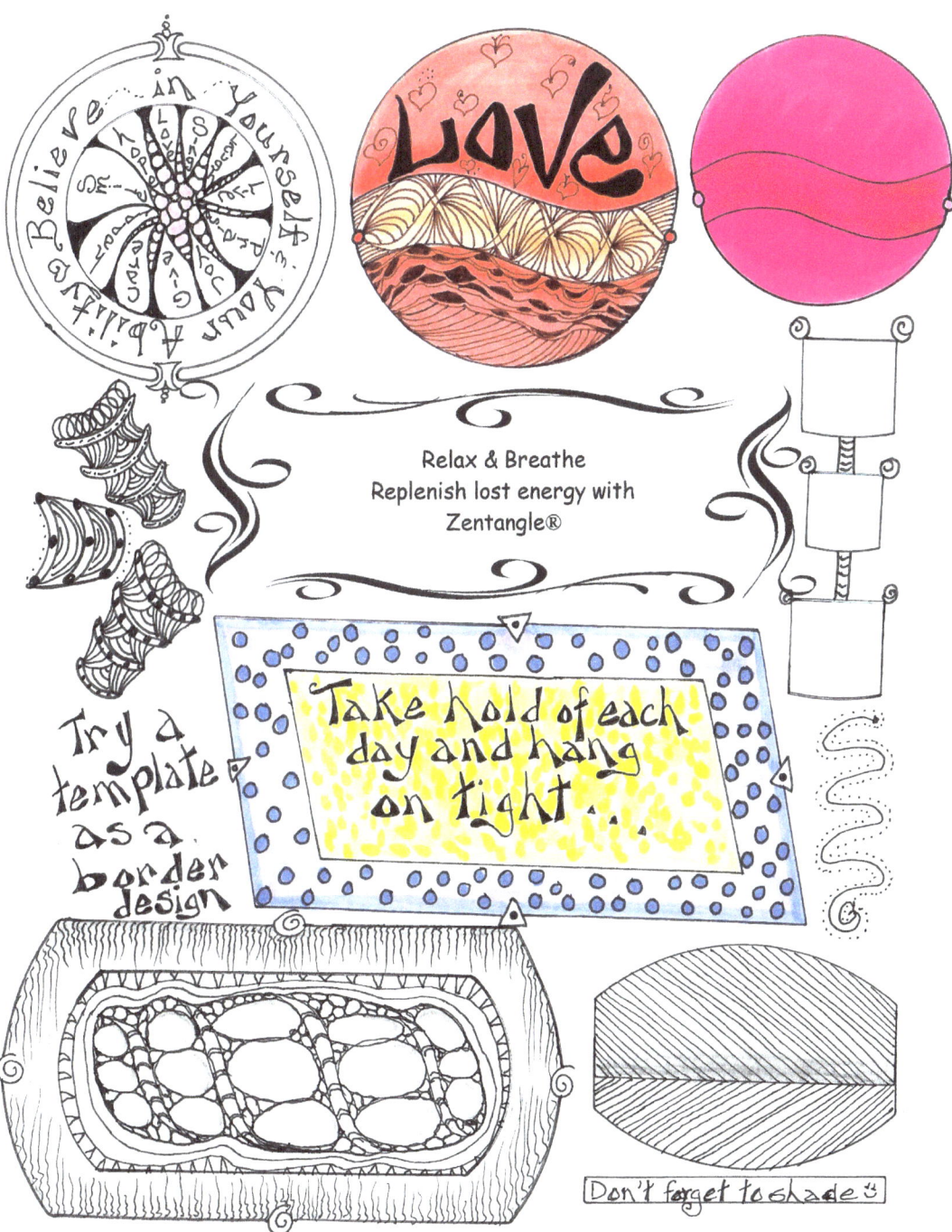

Like every creation, a Zentangle is a unique work of art.

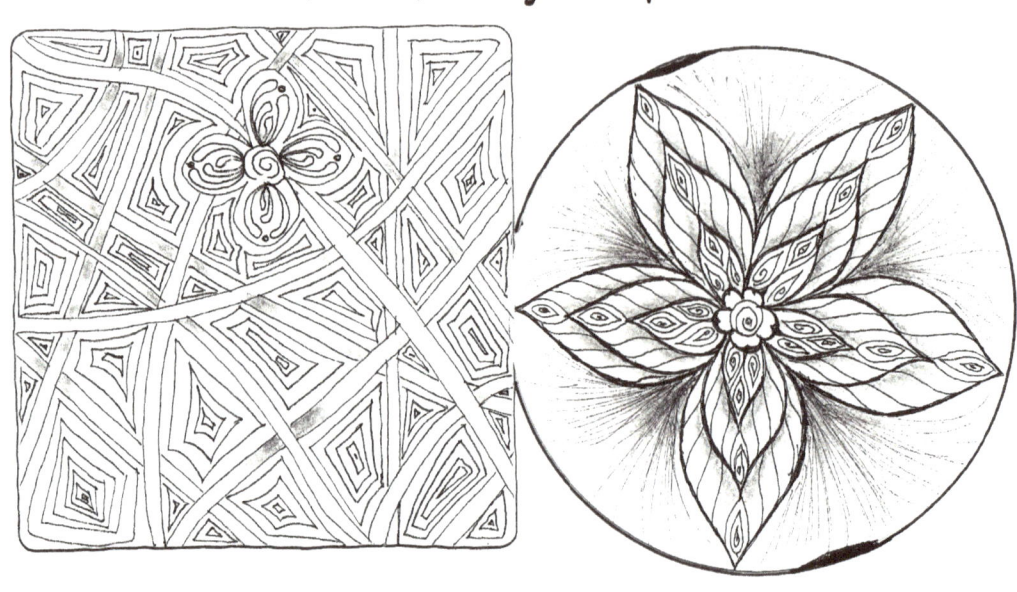

Prepare for new and exciting adventures with Zentangle by tangling often.

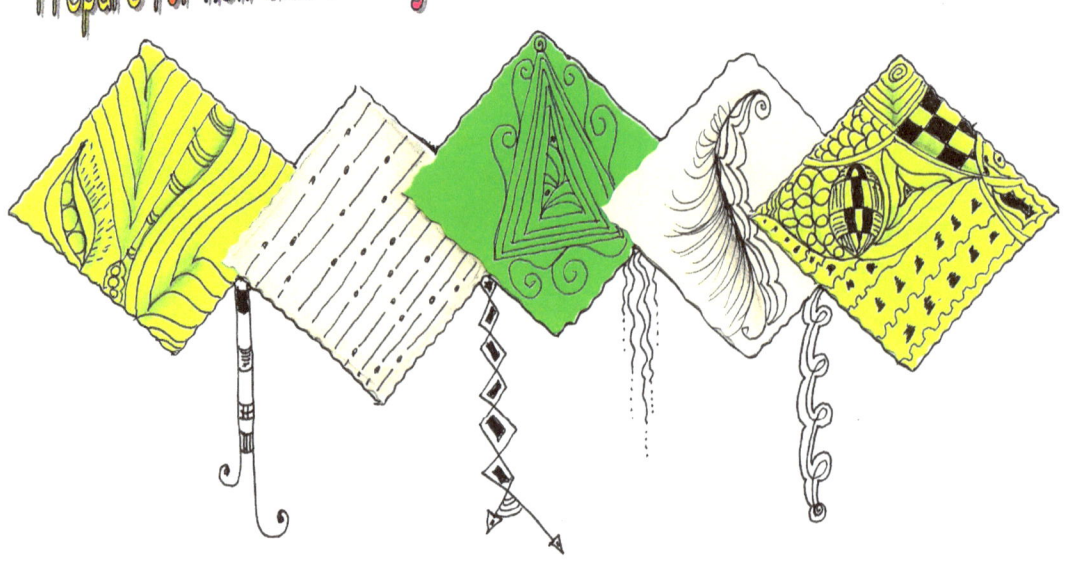

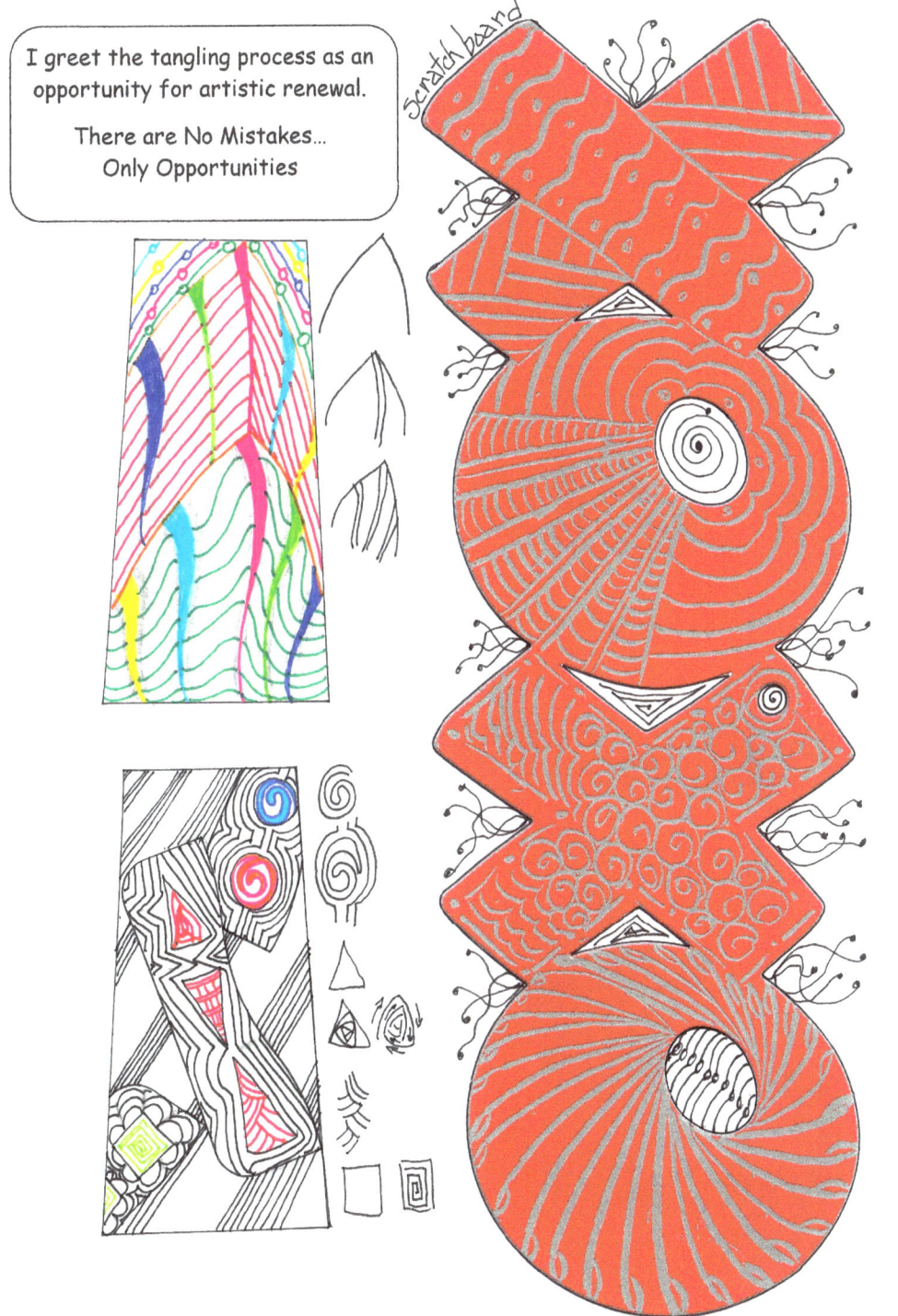

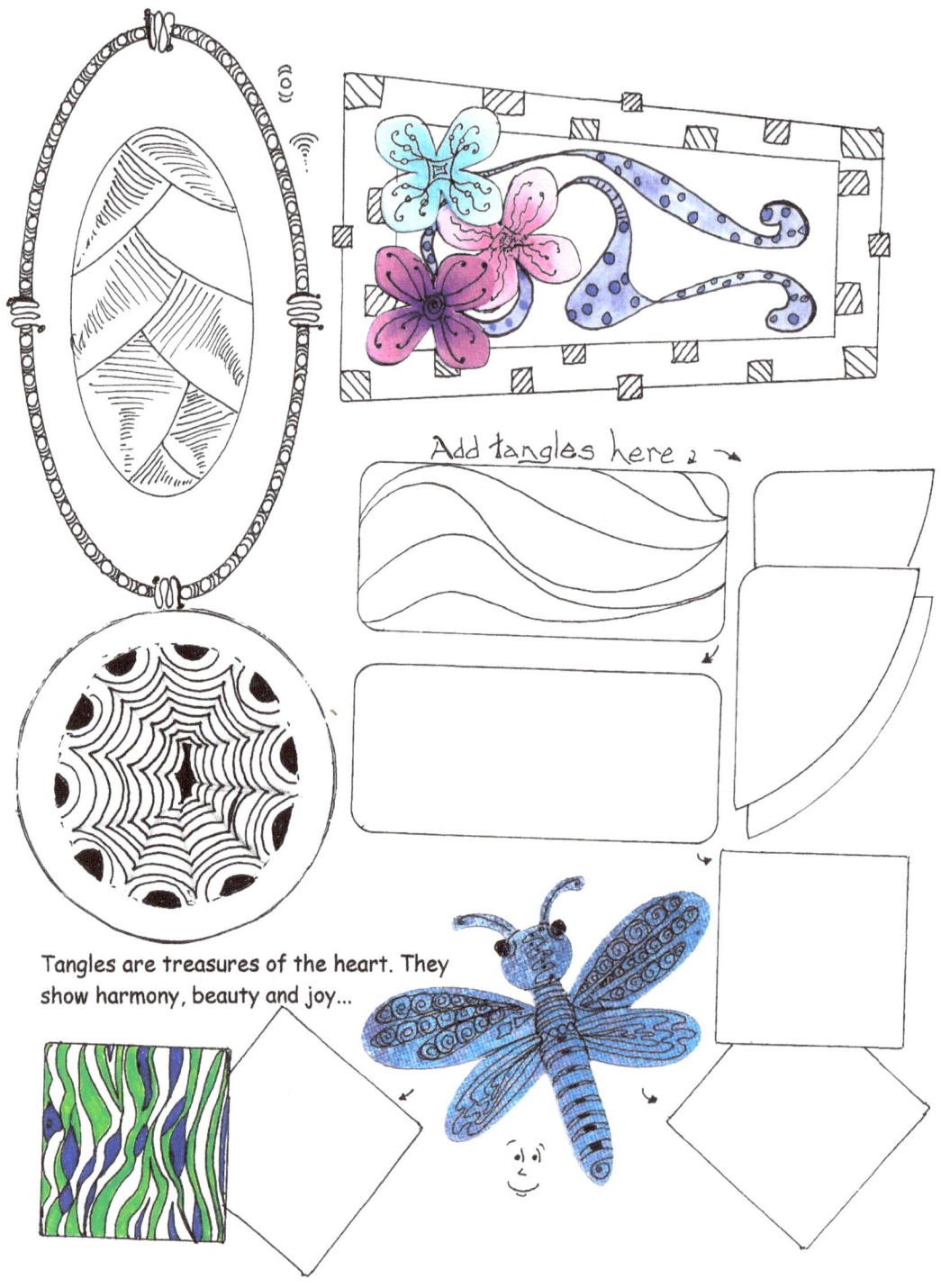

Add tangles here

Tangles are treasures of the heart. They show harmony, beauty and joy...

The inner peace of Zentangle promotes the healing of mind, body and spirit.

Places to tangle..♡....

*Z*entangle restores energy, increases self-worth, and enables creativity without angst.

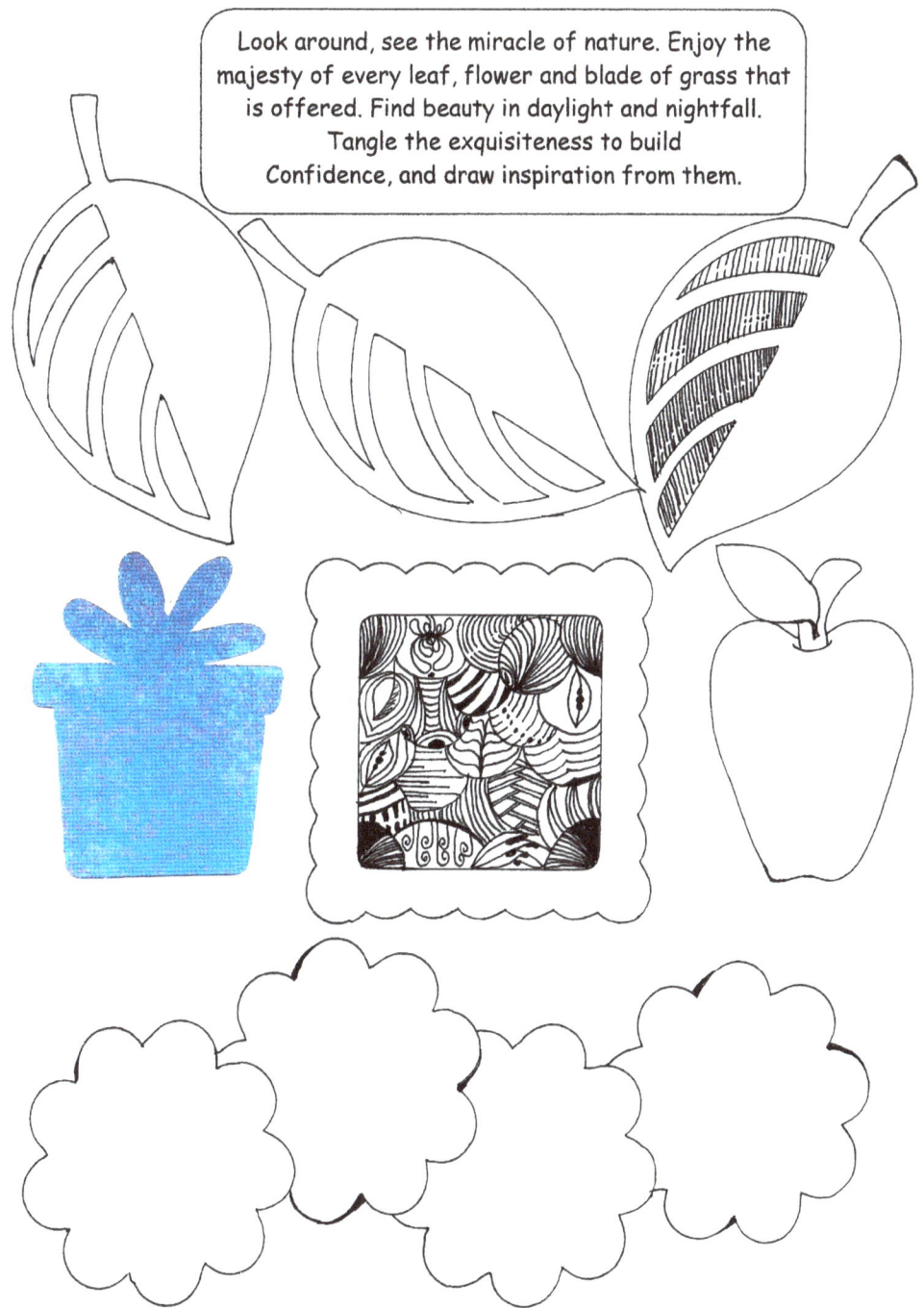

Look around, see the miracle of nature. Enjoy the majesty of every leaf, flower and blade of grass that is offered. Find beauty in daylight and nightfall. Tangle the exquisiteness to build Confidence, and draw inspiration from them.

Gift a tangle to a friend.
They'll be thankful for it!!

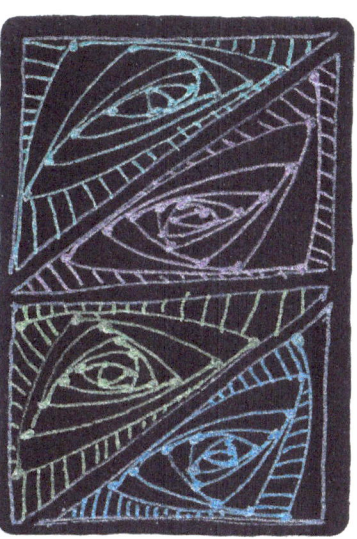

It has been a pleasure to design and assemble this book for you. My hope is that you'll enjoy it as much as I have enjoyed making it.

While tangling won't solve life's problems, it allows us to view them with a better attitude, less feelings of defeat, and most of all, Zentangle® offers us a chance to increase our sense of well-being.

I thank Rick Roberts and Maria Thomas for sharing this wonderful, mindful, art form with me and so many others. Zentangle® has dramatically changed my life, my perceptions, and it has increased my joy in sharing this art with others.

May you find your own joy in the art of Zentangle®...

My best to you, *Jeanne ooo*

www.ingramcontent.com/pod-product-compliance
Lightning Source LLC
Chambersburg PA
CBHW050744180526
45159CB00003B/1346